MW01493847

CHARACTER DESIGN QUARTERLY

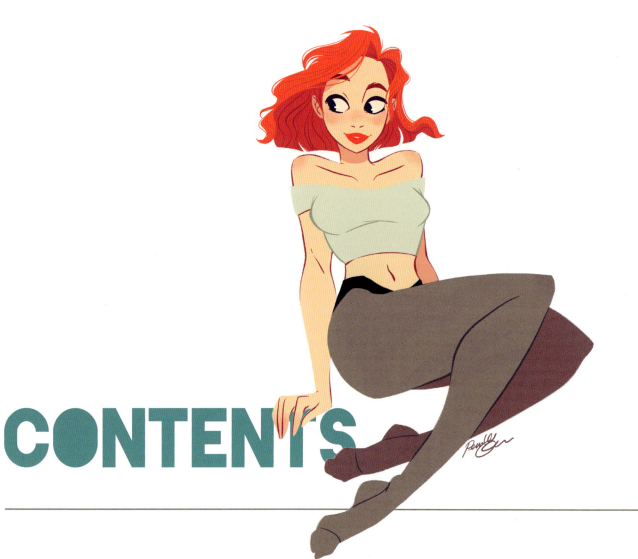

Image © Pernille Ørum

CONTENTS

WELCOME TO *CHARACTER DESIGN QUARTERLY 04*!

As *CDQ* reaches its first "full circuit" of quarterly issues, it is only natural to look back over what has been achieved in these pages so far. Over the past year, *CDQ* has seen some of the world's best loved character designers and artists: from contributors like Lois van Baarle and Meg Park, to cover artists CreatureBox, Gabriel Picolo, and Anna Cattish; from incredible animators and artists like David Ardinaryas Lojaya and the astounding Peter Han in issue 03, to amazing illustrators such as Michał Dziekan in issue 02. *CDQ* has been privileged to feature the work of so many impressive creators. Issue 04 follows this tradition with brilliant cover art from the wonderful Pernille Ørum and features yet more dedicated, inspiring, and talented character designers sharing their experience and expertise. Enjoy!

ANNIE MOSS
EDITOR

Image © Christophe Jacques

Pernille Ørum

As the Lead Character Designer for Warner Bros. Animation's *DC Superhero Girls*, Pernille Ørum took on the enormous challenge of recreating some of DC's most loved superheroes while bringing a fresh look to the existing comic universe. Now a freelance character artist, Pernille continues to illustrate the Warner Bros. tie-in books, but also enjoys the freedom and flexibility of creating characters from scratch.

Pernille is particularly talented at capturing a clear sense of her character's personality and attitude in designs that at first glance appear simple. Her style, influenced by the Disney renaissance and iconic Danish illustrators, is bold, expressive, and nuanced. Having created the fantastic cover art for this issue, Pernille talks to us about her work, how she captures that strong feeling in her designs, and why she likes to keep her drawings loose.

Hi Pernille, thank you very much for taking the time to chat to us today! Please can you tell us a little bit about yourself and your work?

My name is Pernille Ørum and I'm a character designer and illustrator working freelance out of my studio in Copenhagen, Denmark. For two years I was the Lead Character Designer on Warner Bros. Animation's *DC Superhero Girls*, where I helped establish the look of the show and characters.

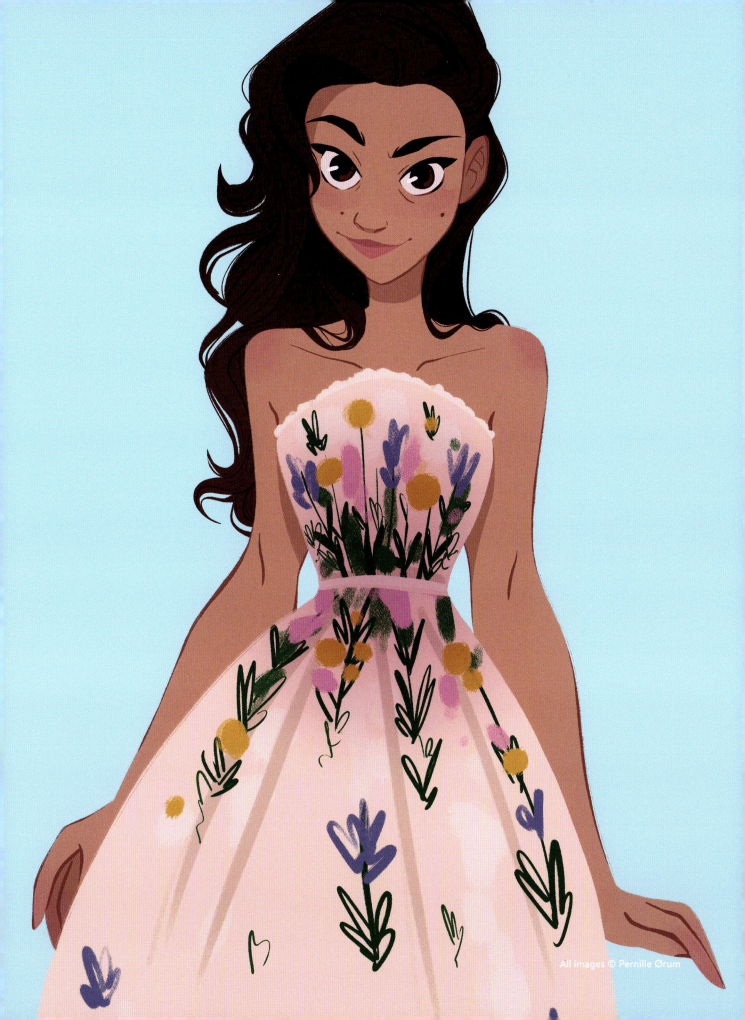
All images © Pernille Ørum

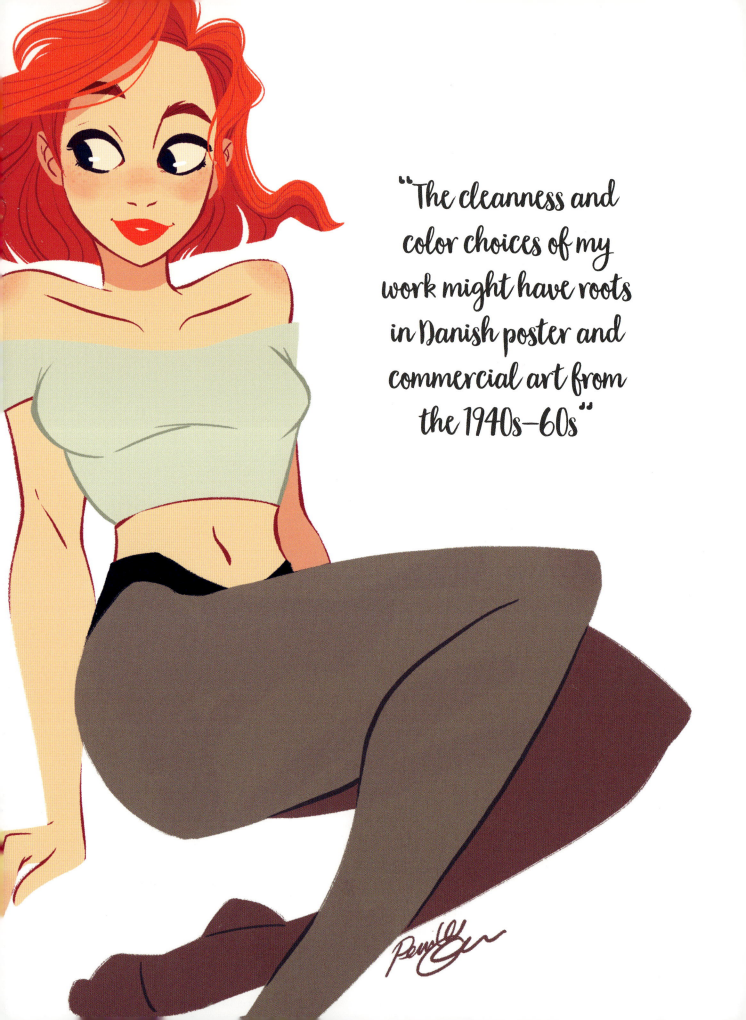

"The cleanness and color choices of my work might have roots in Danish poster and commercial art from the 1940s–60s"

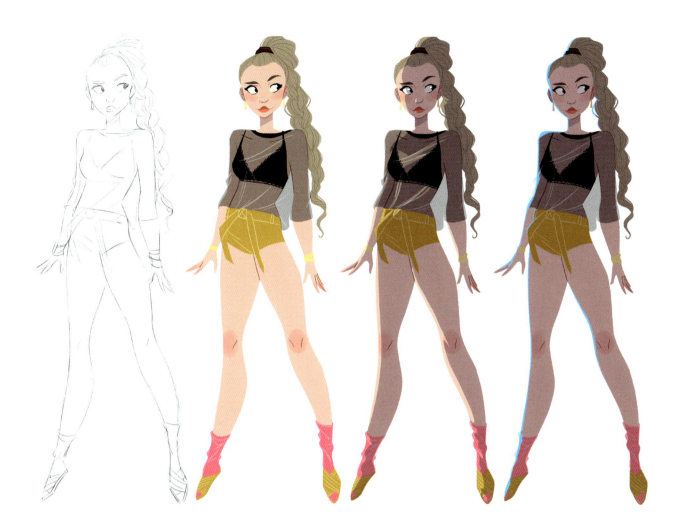

Now I mostly work on character designs in the very early stages of new shows, and I also illustrate books for *DC Superhero Girls*. In 2018 I am working on a personal project too, a comic written by a friend. It is a new challenge which I am very excited about.

Wow, that's a lot going on! Does your design process differ between working on animation, book, and comic projects?

Currently I don't experience much difference between projects, but I tend to illustrate with the character as the focus which creates consistency. I have done some visual development previously, and I approach books in the same way now by communicating a mood and narrative.

I think the new comic is going to be a very different way of working however, and I hope

my experience working with storyboards will help me. I'm definitely going to be in deep water, but the challenge is the fun part.

Speaking of focusing on the character, your character designs are so bright and clean; what inspires this fresh style? Which elements do you concentrate on when conveying expression?

I grew up during the Disney renaissance and it had a great influence on my personal style. I've also looked to other art forms though and tend to find inspiration everywhere I go. Fashion, travel, and traditional painters like Vermeer, Klimt, and Caravaggio are always a source of inspiration to me.

However, the cleanness and color choices of my work might have roots in Danish poster and commercial art from the 1940s–60s. The work

of artists like Viggo Vagnby, a famous poster artist, can still be seen everywhere in Denmark to this day.

The expression is often the first thing I get into when starting a new drawing. If I capture the feeling of the character at this point, the rest of the process is easier. To get that sense of expression I love playing with the lines, removing them and simplifying the design, without losing the feeling I am first going for.

Previous spread: *Flower beauty*

Left: An image created for the *CORAL* Kickstarter campaign

Above: Building a character image

Going back to your work on DC Superhero Girls, what was it like working on characters for such an expansive (and popular) universe? What are the challenges of creating new characters in an established genre?

Most of the characters I designed were already created so I had to redesign them, which was a big challenge. You want to make the designs your own while being true to the original characters. When reinventing characters with such a large fan base, you also want your vision to add something to the fans' existing visions. Creating an original character doesn't have the same pressure because you define what the character looks like, and who he or she is.

In 2016 you fundraised for the Red Cross though the sale of an exclusive print, to support their work in Aleppo (a great achievement). Do you plan to do more charity work again in the future?

Yes, I was so happy with the support and contribution I received during that project. It was amazing to experience the willingness of people to help. I have been thinking about doing it again, but it did take a lot of work when it was just me, so it's not something I'll do again right now.

Instead, I have recently contributed a piece of artwork for a book that Paul Schoeni, a fellow artist, has put together to raise money for Save The Children. It's called *Beginnings* and collects artwork from more than sixty artists. You can purchase *Beginnings* from the book's fundraising page on crowdrise (www.crowdrise. com/o/en/campaign/beginningsartbook).

You mentioned the comic will be a new challenge for you. How do you ensure that you continue to develop your skills and techniques?

I try to draw every day and keep good working habits. If I take a longer break I find it takes time to get back into drawing; it's like a muscle that needs to be exercised. If I lose inspiration I often look to drawing challenges like MerMay, Inktober, and Sketch Dailies which challenge you, but also give you a sense of community.

Also I try to be curious; do not assume that you know it all! Ask other artists how they achieved their result. Be specific, however, when asking for advice by first identifying the thing you are struggling with.

Techniques can be very individual depending on where everyone is coming from. However, I would suggest keeping your drawings loose and avoid overcomplicating the design. Even if your style is very detailed and involves a lot of rendering, if you lose the main shape, you lose the design.

In my style, I basically stop when the character is defined because I don't enjoy rendering and I like the visual style of simplicity. This doesn't mean it is easier though, because with this style there is nowhere to hide.

Below left: *Anger*

Below right: The cover art for *CORAL – The Art of Pernille Ørum*

Opposite: *Yellow*

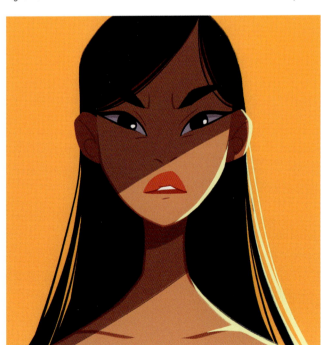

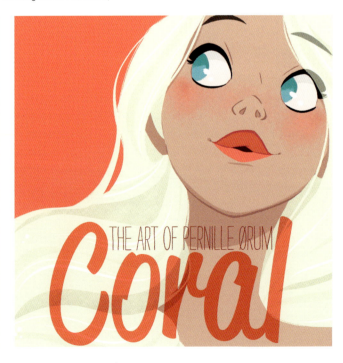

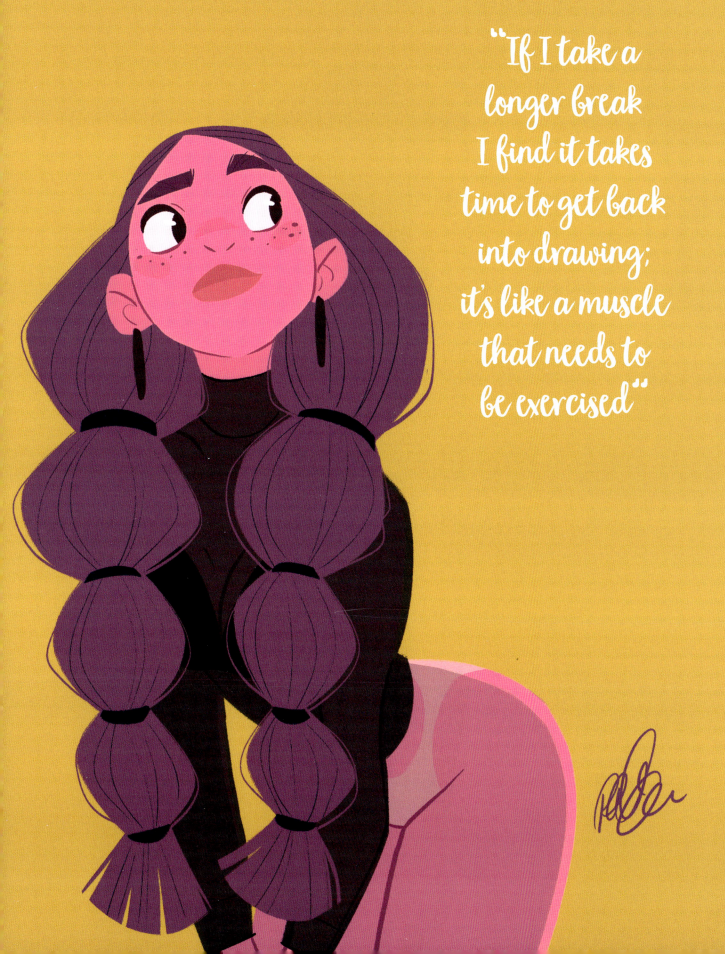

"If I take a longer break I find it takes time to get back into drawing; it's like a muscle that needs to be exercised"

"Producing an artwork is a creative, sometimes frustrating, process but the more you enjoy it, the more engaging the piece becomes"

That's good advice, thank you for sharing. If you had the opportunity to give younger self one piece of important guidance, what would it be?

It took me a long time to learn to loosen up when drawing so I would tell myself that the drawing doesn't have to be perfect at the first stroke. I'd encourage my younger self to be loose and have fun with it. Producing an artwork is a creative, sometimes frustrating, process — but the more you enjoy it, the more engaging the piece becomes.

Also, do not be afraid to show your work. Start sharing your designs and have people be a part of your journey. It will help you grow faster as a designer and you can enjoy being part of a community.

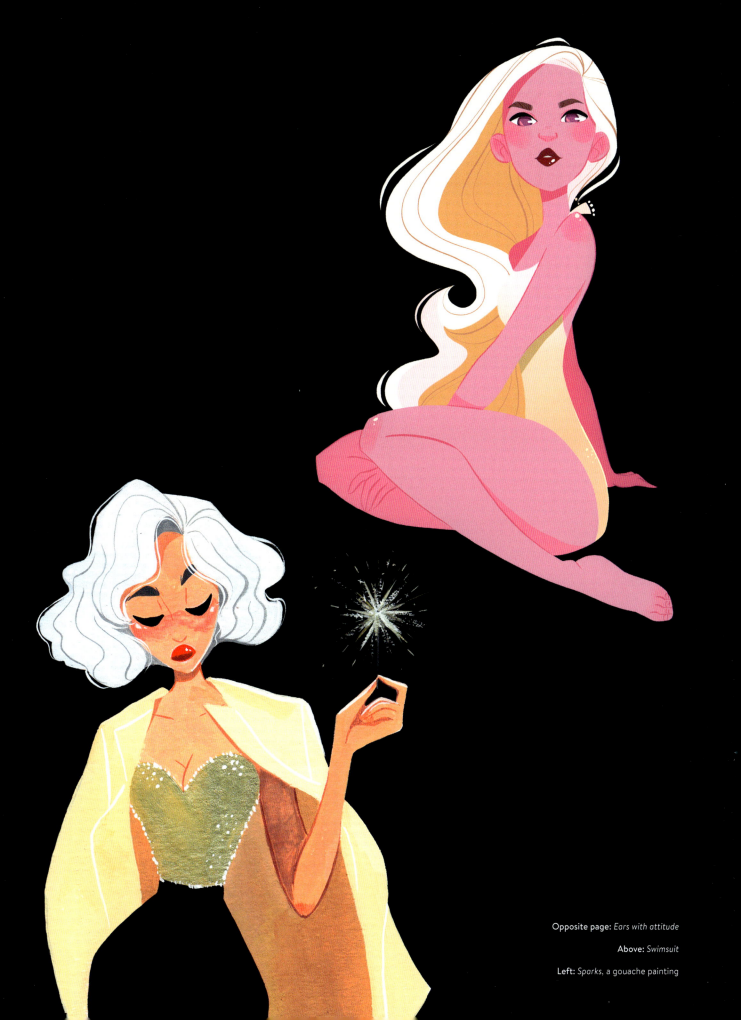

Opposite page: *Ears with attitude*

Above: *Swimsuit*

Left: *Sparks*, a gouache painting

STYLIZING YOUR DESIGNS

Nikolas Ilic

When creating stylized characters there are many things to consider before you get to the finished design. In this mini-article you will learn the key design elements that will help to define your character: silhouettes, expression, posing, shape, contrast, and props. All these elements will define your character's story, personality, and visual appeal.

It is important that stylized characters can be read instantly. This is where your character's silhouette becomes essential. The design of this dog has a very clear silhouette, for example. If this design was just a pure black shape, his tail, ears, nose, mouth, and feet would all still read very clearly.

Using both shapes and contrast in a design will keep the characters stylized and interesting to look at. These rock trolls are based on three simple shapes: a circle, square, and triangle. Limiting your designs to simple shapes gives the viewer a clear and instant read of the character. You can then use contrasts within the design when determining where the legs, arms, eyes, nose, and mouth are placed. Exaggerate the proportions of the design which will help to create interest and personality.

Giving the design color is an important tool to help reinforce the character. With this Russian general, you can see that he is a military man not only by his uniform but also through the color palette. If his jacket were a bright yellow color, for example, it could instead be interpreted as a rain jacket. Knowing the colors you need to work with in advance will make the character more successful as a design.

In this design, props are used to further the character's story and personality. Adding bottles and broken bottles to the scene implies he is quite a drinker. Furthermore, making his nose a pinker color helps to merge the character and props together, as if he had been drinking all day. It is subtle things like this that help to create a character rich with personality.

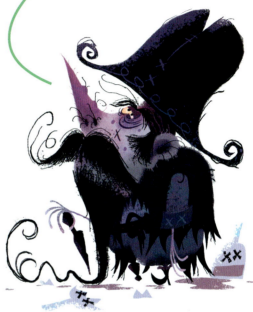

Posing characters is a key component of the design process. It can give the character a story and bring them to life. In this design, we can see a fox in an exaggerated running pose with a bag full of chickens on his back. This design could have been presented with the character just standing upright, but having a strong pose like this gives a greater sense of the character's life and story.

Expression is important when communicating to the viewer how you want the character to be seen. In this caveman design, he has a very stiff and stern look. Giving him a low brow and a straight mouth reinforces that expression. Even giving the character a closed fist helps to sell his expression of sternness.

Connect with the character

When working in the industry as a character designer you must love what you do! Creating characters is not always about making the character appealing. First you need to connect with the character and find their personality so that you can express what they are feeling to the viewer. A drawing can always be made to look appealing, but first you have to know what your subject matter is and what their story is.

All images © Nikolas Ilic

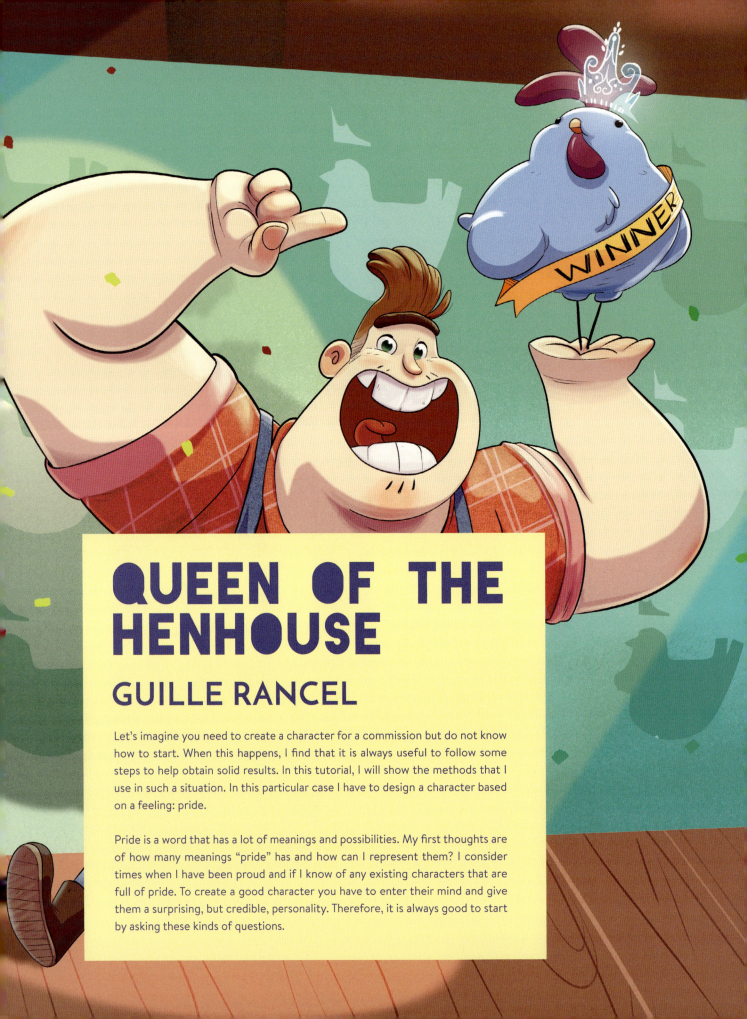

QUEEN OF THE HENHOUSE

GUILLE RANCEL

Let's imagine you need to create a character for a commission but do not know how to start. When this happens, I find that it is always useful to follow some steps to help obtain solid results. In this tutorial, I will show the methods that I use in such a situation. In this particular case I have to design a character based on a feeling: pride.

Pride is a word that has a lot of meanings and possibilities. My first thoughts are of how many meanings "pride" has and how can I represent them? I consider times when I have been proud and if I know of any existing characters that are full of pride. To create a good character you have to enter their mind and give them a surprising, but credible, personality. Therefore, it is always good to start by asking these kinds of questions.

PRIDE

DEEP PLEASURE SATISFACTION ACHIEVEMENTS

BY MYSELF **BY OTHERS**

DIGNITY/ RESPECT FOR YOURSELF

ARROGANCE, VANITY, EGO

EXPLORE THE CONCEPT

Pride is a word that could have several meanings. That is why I think it is a good idea to start by making a quick brief to help think through the different options available. Defining some boundaries will spark your imagination and enable you to create sketches that will form the basis of the final design.

The character could be proud of themselves or of the achievements of their loved ones. Maybe he or she is an arrogant or vain person. This exercise offers the chance to consider different possibilities so do not throw out any ideas you dislike just yet. Make a diagram containing all those meanings and start to sketch the first things that come into your head. All this preparation will help to begin developing the vague ideas.

LOOK FOR REFERENCES

As this character needs to convey a particular emotion, I start to think about body shapes and stances that suggest pride. Going for a walk or surfing the internet can help discover relevant references. Google Images and Pinterest are immensely useful for finding reference images. I start looking for body poses that could support the concept of pride.

You have to consider three important things in posing: a dynamic line of action, a recognizable shape, and the sensation of weight. These must be quick and easy to comprehended at first sight. Try to create some fresh ideas, but also develop the previous ideas.

Top: Use a diagram to explore the concept and its possible meanings

Left: Create some body shapes and poses that suit the pride concept

SKETCH SOME IDEAS

After warming up and looking for references, create new sketches while keeping in mind the character ideas developed so far, and the story you want to tell. Pride must be the core emotion of the concepts now, and the main attribute of the drawings.

Think about each character, and ask why he or she is so proud. Pick a few ideas and create little stories for them. For example, I think of a cactus that is proud of his newborn daughter, and a young female hunter who collects huge dinosaur femur. Create characters who have a strong personality; something that makes them unique and charismatic. As you draw, think about the kind of world this character inhabits.

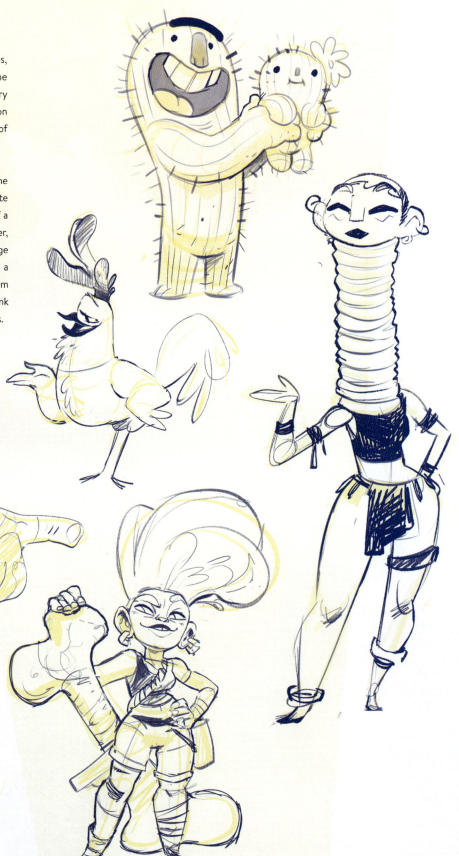

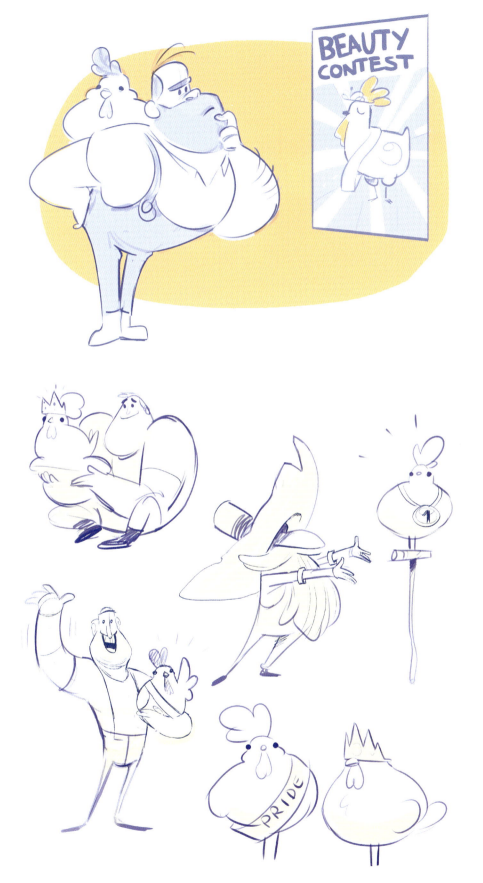

CREATE A BACKSTORY

Now consider, which of all these imagined stories and worlds is your favorite? Write a short plot based on it to give the backstory more depth, and to offer as a reference as the character progresses.

I decide to design a farmer that feels deeply proud because his chicken is the winner of the Big Beauty Contest of Eggplant Bay County. Even though there are two characters here, they must work together as one complete concept. Humor is the foundation of the story I want to tell.

When working on a backstory, think about the kind of stories that inspire you. Do you like comedies? Or do you prefer drama? Maybe you want to include some action scenes. Choose an idea and see where it will take the character.

SKETCH YOUR NEW CHARACTER

Now a narrative path has been chosen, start to walk down it. It's a good time to start asking more specific questions about the character. How old are they? Do they work? Who are they?

Think about how these details affect their physicality. What attributes need strengthening? Is the character young and dynamic? Or old and weak? Create a link between the character and his reason to be proud: the chicken. Consider different scenarios that will support the main idea. The sketches must feel alive and full of emotional energy.

Opposite page: Create some sketches based on interesting concepts

Top: A farmer and his chicken looking at a beauty contest poster is the backstory to this proud character

Left: Different physical shapes and ideas for the farmer and his chicken

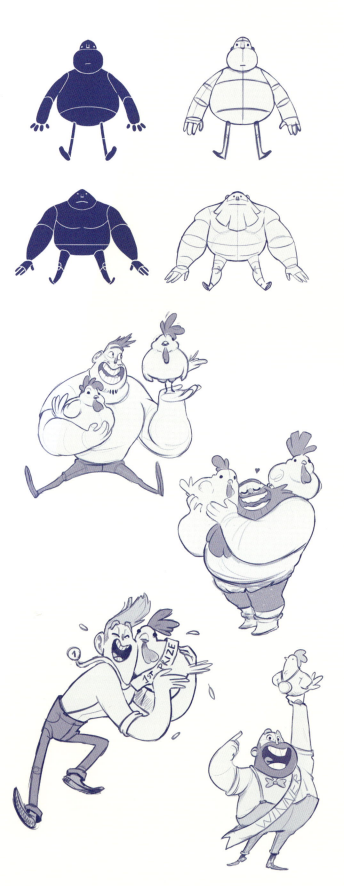

BUILD THE BASIC SHAPES

It is possible that the basic shape of the character has already been decided, but regardless, it is useful to play around with shapes and draw some variations. These shapes are going to give support to the character's personality.

Round shapes will strengthen the kind and happy behavior of my proud chicken farmer. He will have long arms and a big body, but he has a small head and short legs. This contrast between shapes makes a character more interesting.

Start the exploration by working out simple shapes first such as spheres, cubes, and cylinders. Do not start with detailed sketches; always work from the general to the specific.

DEVELOP THE CHARACTER

Experiment further with the shapes until the design is settled. Make some additional sketches showing the body shapes in vibrant and exciting poses. This will help to show how the basic shapes may look in the final character design.

It's possible to also ask a few new questions about the character; what if he has two chickens instead of one? If the chicken did not win the beauty contest would the farmer still feel proud? Keep in mind the core concept of the design, in my case pride. It must be the focus of the design and represented in the pose. This process will help the better understand the character.

Top: Try simple shapes first when creating the character

Left: Some energetic poses. Work with the shapes created previously

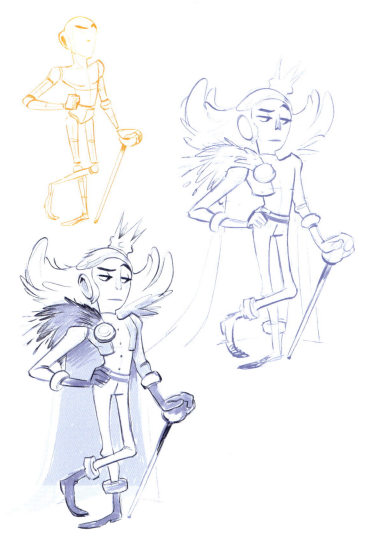

IDEAS TRASH CAN

One of the ideas for this design I rejected was a proud, despot-like, teenage king. I liked the design and the feeling, but the concept seemed too obvious. I am sure many designers have thought along the same lines as me for this sort of character.

As I worked on it, I looked at myself in the mirror and I tried to act proud and full of vanity. I looked for some references and old sketches to help but eventually, I rejected it because I preferred to do something funnier.

DETAIL THE BASIC SHAPES

Once the basic shapes are chosen, they need improving. Use symmetry to build the structure as this will help to create the character faster.

Keep in mind that the design will need to have a solid structure and volume. Build it from basic shapes first, and then define key areas: elbows, knees, waist, shoulders, and neck. Then add details that break the symmetry to make the design more eye-catching. Add asymmetrical clothes, hair, and facial details. However, forget about unnecessary items if they add nothing to the drawing. Overall, keep the design as smooth and simple as possible.

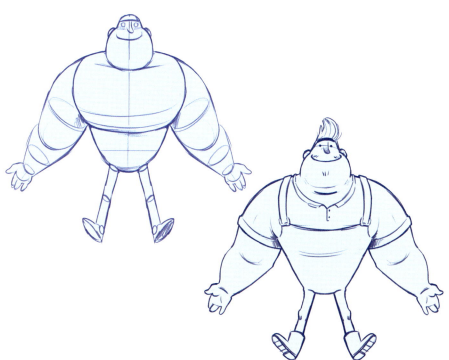

Left: Work first with basic shapes and symmetry, then add details that enhance the design

MAKE A SOLID DESIGN

It is time to define the character details. This step creates a set of rules that will determine who the character is. Keep in mind that this step can help others who may work with your designs, such as modelers or animators, so make the design and notes as understandable as possible.

Create a turnaround drawing to discover how the character looks from each perspective. Define their haircut and the clothing. Create some quick sketches for the hands to define the main shapes. This will show if the character needs some improvements. It is important to dedicate as much time as necessary to complete this step.

This page: Work on the details more and solve the possible issues in the design

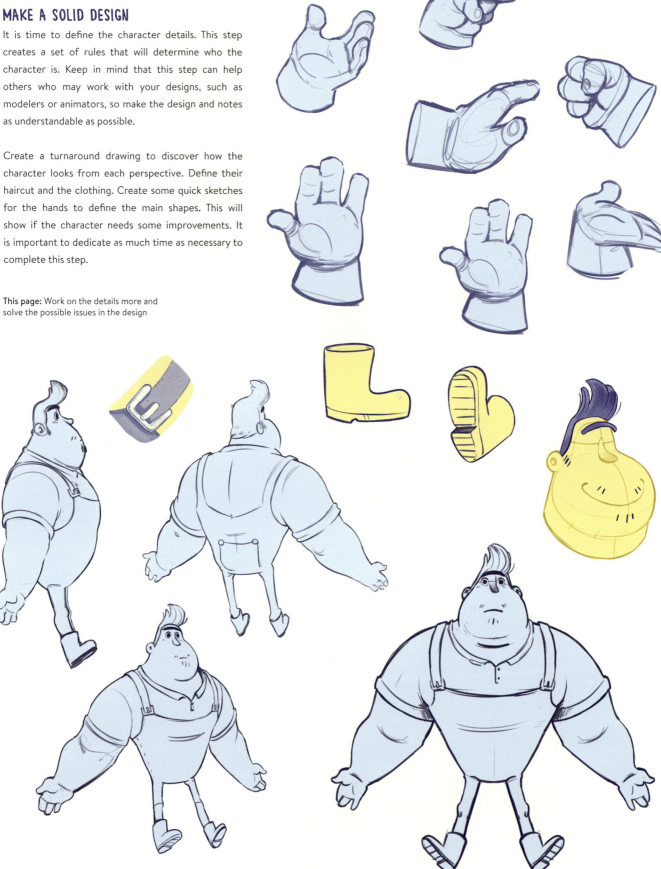

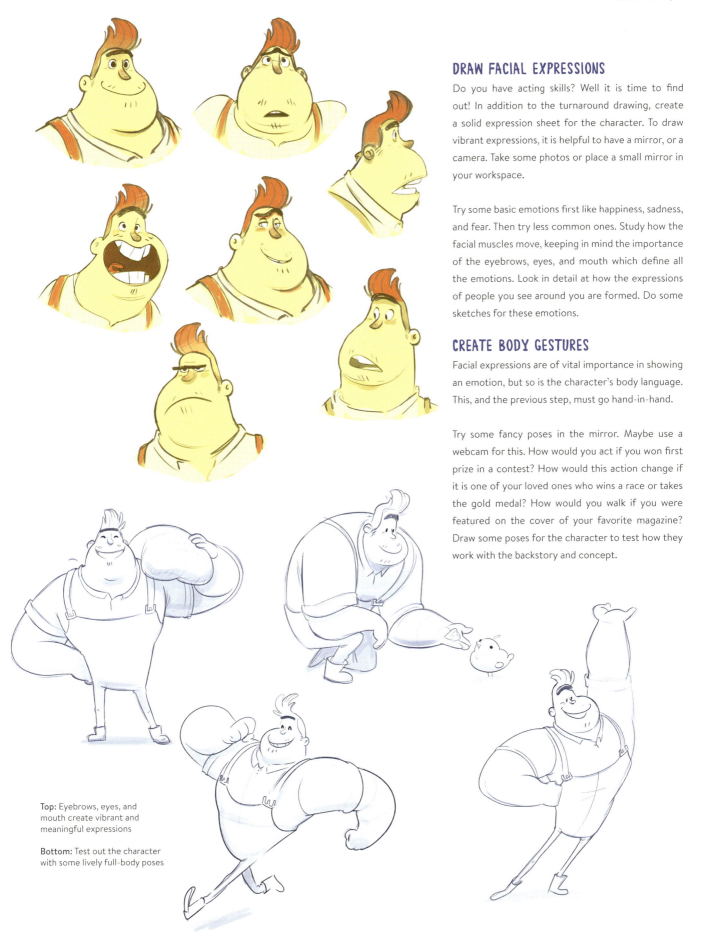

DRAW FACIAL EXPRESSIONS

Do you have acting skills? Well it is time to find out! In addition to the turnaround drawing, create a solid expression sheet for the character. To draw vibrant expressions, it is helpful to have a mirror, or a camera. Take some photos or place a small mirror in your workspace.

Try some basic emotions first like happiness, sadness, and fear. Then try less common ones. Study how the facial muscles move, keeping in mind the importance of the eyebrows, eyes, and mouth which define all the emotions. Look in detail at how the expressions of people you see around you are formed. Do some sketches for these emotions.

CREATE BODY GESTURES

Facial expressions are of vital importance in showing an emotion, but so is the character's body language. This, and the previous step, must go hand-in-hand.

Try some fancy poses in the mirror. Maybe use a webcam for this. How would you act if you won first prize in a contest? How would this action change if it is one of your loved ones who wins a race or takes the gold medal? How would you walk if you were featured on the cover of your favorite magazine? Draw some poses for the character to test how they work with the backstory and concept.

Top: Eyebrows, eyes, and mouth create vibrant and meaningful expressions

Bottom: Test out the character with some lively full-body poses

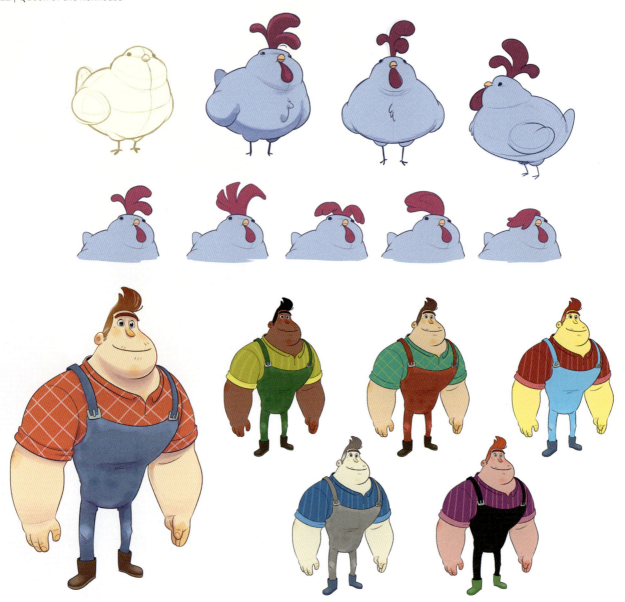

WORK ON THE DETAILS

Now I am going to focus my attention on the prize-winning chicken since she is an important part of the overall design. I have always felt that chickens are comical but lovely creatures and I want to represent this in my design.

Her round body shape indicates that she is kind and harmless. She has tiny, widely separated eyes so she does not seem to be very smart. That will reinforce the idea that she is not really conscious of her triumph. I then try different combs, emulating various hairstyles, to make her appearance funnier. Play around with the different feature elements of a character in this way to add some extra personality.

LET'S COLOR!

It is time to color the designs. To do this, I create a three-quarter pose to try different color variants on and explore different tones. Textures could also be added at this point if it improves the designs.

If working digitally, play with color layers and make hue variations. Alternatively, try using different palettes of colors. Do not be afraid of creating extreme variations in the skin tones, clothing, and details. When happy with one, add lights and shadows.

Keep in mind that colors can have implied meanings, and there are cold and warm shades. Think carefully about which colors fit better on the drawing.

Top: Work on details that will reinforce the character

Bottom: Add color and try some variations and palettes

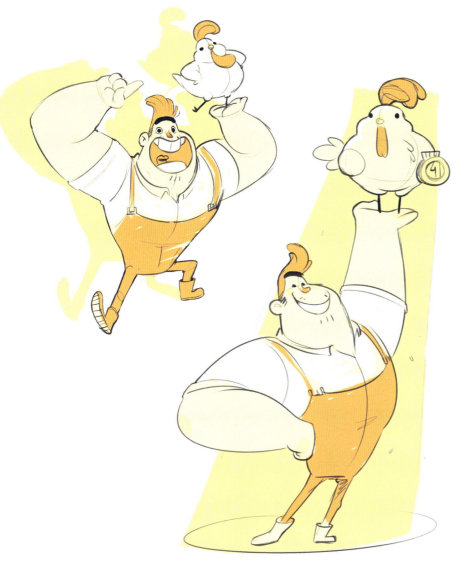

SKETCH THE FINAL IMAGE

It is time to create the final image, so let's start doing some sketches for the presentation scene. First of all, the farmer's pride has to be represented in the scene somehow. To keep the key ideas in mind as I draw, I recover some of my previous sketches or quickly create some new, rough sketches.

Consider which drawing best represents the concept. Think too about the storytelling as the scene is pulled together. While sketching, try some dynamic poses that are full of emotion. Remember to aim for a vibrant line of action and that has a strong silhouette.

This page: Create some scenes, keeping in mind the message being conveyed

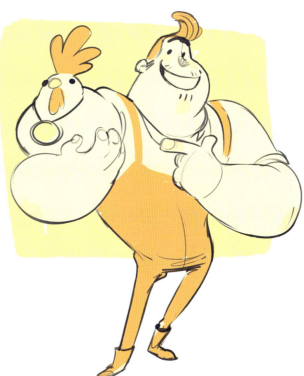

CREATE THE FINAL IMAGE

Choose a scene sketch, clean it up, and develop it a little further. Review the previous steps one more time to ensure the design is consistent with the concept. You should aim to tell the backstory without using words, so the viewer will not be left to wonder what is going on when they see it.

In my chosen scene, the farmer is extremely happy and proud because his chicken has been selected as the most beautiful chicken in the county. They are on stage and the animal is wearing the winner's sash and a beauty queen's crown. To give the scene some additional context, there are two chickens behind them who look on with curiosity.

This spread: The final design presented in a scene that helps to sell the design concept

FINDING THE FAULTS ▶

This happens all the time: there is something wrong with your drawing and you do not know what it is! Maybe it is the proportions, pose, or expressions; you are only certain of there being something that is not working.

In this case, try not looking at it for a few hours and then look at it again with fresh eyes. Or, show it to some of your friends and ask them for honest feedback. Sometimes they will say something that you had not thought of before. You could also try flipping the design horizontally and vertically to reveal some issues or mistakes that had not been noticed before.

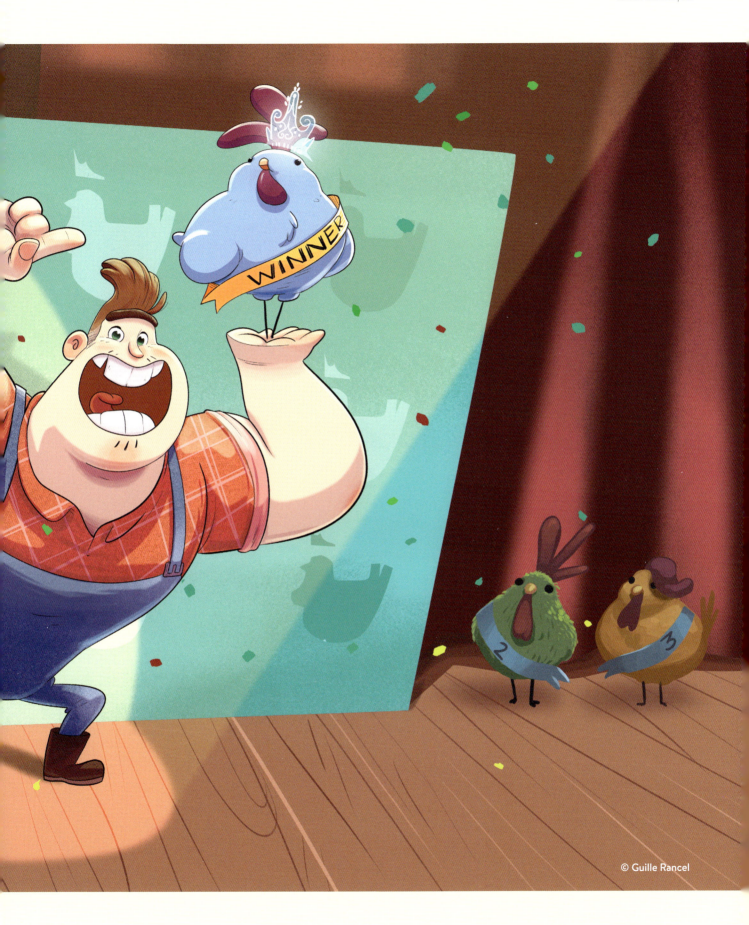

© Guille Rancel

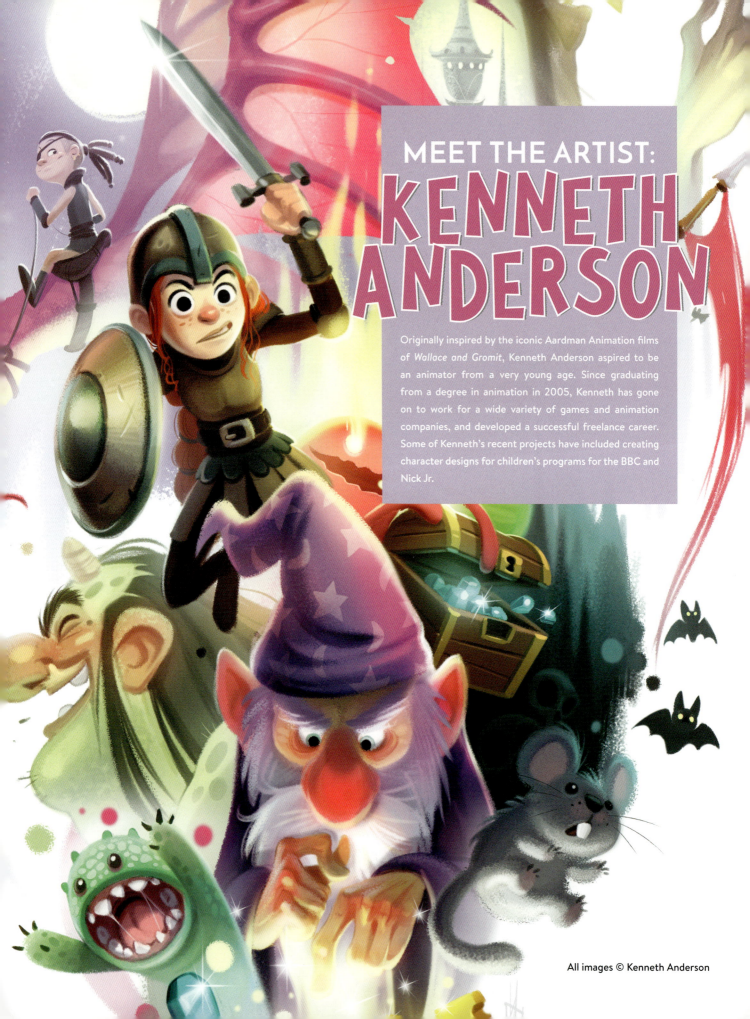

MEET THE ARTIST:
KENNETH ANDERSON

Originally inspired by the iconic Aardman Animation films of *Wallace and Gromit*, Kenneth Anderson aspired to be an animator from a very young age. Since graduating from a degree in animation in 2005, Kenneth has gone on to work for a wide variety of games and animation companies, and developed a successful freelance career. Some of Kenneth's recent projects have included creating character designs for children's programs for the BBC and Nick Jr.

All images © Kenneth Anderson

This page: The orangutan is Kenneth's favorite animal. This sketch was drawn to practice his skills

Opposite page: A crop of one of Kenneth's imagined scenes

With a wide interest in the different methods that can be used in animation productions, Kenneth has developed his skills by exploring the capabilities of traditional 2D drawing animation techniques, digital 2D processes, 3D animation, and also stop-motion animation practices. As well as exploring these different mediums, through his freelance career Kenneth has been able to adapt to a range of styles, and in doing so has maintained a flexibility of style that has helped his career to flourish.

Here, Kenneth chats to us about the limitations of different animation processes, the things that have helped his freelance career grow, and how developing his style is important to the work he now does.

Thanks for talking to us today! Please can you tell us about yourself and where you are from?

Thank you for the interview, it is an honor! I love your magazine. I am a character designer and illustrator living and working in Glasgow, Scotland. I have been interested in drawing all my life, inspired by things like *Calvin and Hobbes*, *Teenage Mutant Ninja Turtles*, and the *Monkey Island* games I played as a child. When I was about eleven years old, I became obsessed with *Wallace and Gromit* and I knew then that I wanted to pursue a career as an artist, preferably in animation.

After high school I studied animation at Duncan of Jordanstone College of Art and Design, in Dundee, a small city on the east coast of Scotland. My main focus while studying was on 2D traditional pencil-on-paper animation techniques, but I also had the chance to experiment in stop-motion and learn some basic 3D animation skills.

I have been working in some form of design field since I left art school. I started out as an artist in mobile gaming before moving into traditional animation, and then into freelance character design and illustration.

You also studied anthropology briefly which sounds very interesting! Has this been useful to you in terms of your character design work or career in any way?

The main reason I decided to do the course was because of my great interest in other cultures and the world around me. I love to travel so that was also an influence on my decision. In hindsight, it was definitely useful in my character design process. It taught me to see the world differently and to be more sensitive when portraying other cultures. Animation sadly has a history of relying on cultural stereotypes and creating inappropriate portrayals as a result.

It also taught me to understand the complexity of characters, from within. Human beings are so complex culturally. We are not just products of our individual experiences but also of the societies and cultures which help shape us, and which we can in turn also influence.

Anthropology tries to understand why people behave the way they do in a society. A particular culture might influence how a person acts in any given situation, how they think, how they talk, what they believe about the world and what they desire in life. That desire is crucial, it is the building block of conflict, and conflict is the foundation of good storytelling.

So the course taught me about the complexity and variety of human nature. I try and bring some of that into my work if I can. Character design isn't just about making nice lines on a page, it took me a while to learn this. It is about character first and foremost; the story behind the drawing. The design should always support that.

What is working freelance like and what types of clients have you worked for?

I officially went freelance in 2009, although I tend to switch between freelance life and full-time employment depending on the opportunities that arise. I recently took on a full-time contract but for the past four years I have mostly worked freelance.

When I started freelancing, I was taking on anything I could find – bits of character design for local games companies, or the odd commission for people who found me via my blog, social media, and website. It took a few years to really get going, but over some time I started to get bigger clients and more consistent work. As a result, I've done a range

of things from designing characters for games to illustrating a board game, as well as some magazine illustrations.

Since 2013 I've found myself mainly designing for children's television, working on a variety of shows for different networks. Usually I work on character designs or character development but I also do the odd piece of environment design and a bit of prop design.

In the past couple of years I have been fortunate enough to work with the BBC, Nick Jr., Sesame Workshop, Imagine FX, and Brown Bag Films, who I am currently contracted with. Most of my clients and work are for the animation industry, with the odd editorial or games client as well for variety.

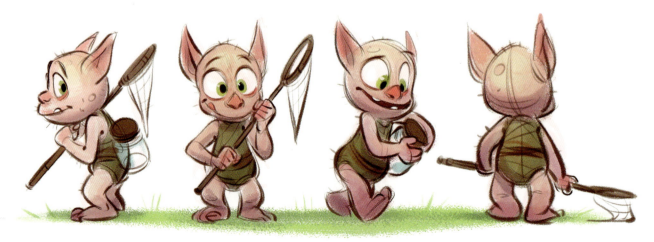

This page: A recent illustration drawn of an emotion and moment of inspiration

Opposite page (top): A super quick drawing to maintain the energy and motion of the design. Sometimes loose sketches work much better than time labored pieces

Opposite page (bottom): It's good to take a character doodle and turn it in 3D space using interesting poses

What helped you build up your freelance career?

If I am honest, I am not entirely sure! I think it may have been a combination of having a web presence and word of mouth. Ever since I started freelancing I have maintained a website and some form of social media presence. I started out on Blogger, and then moved into Tumblr, Twitter, Facebook, and more recently Behance. I don't use Blogger much now but at the time I was using it there was a large network of artists with blogs and it was quite easy to connect with people. How much of that actually translated into client work however is hard to say.

I did get some freelance work through people I knew in the industry; my first freelance character design job was with a Dundee games company and I had worked with one of the guys there before (thanks Danny). Later down the line I got work through recommendations from people I had work experience with. Having these connections really helped.

I also experimented with sending out postcards or emails to people I would like to work with but, as far as I can tell, I never got any work from these methods. Most, if not all, of the work I have gotten as a freelancer has been from people reaching out to me.

I think having a website which was Google search friendly, so that relevant people could find my website easily, probably helped the most. Added to that I constantly updated my blog and this made it fairly easy to get some attention. My goal when I started my website and blog was just to do my best work and hopefully clients would come to me. That slowly started to happen over the years but it took time and a lot of updating.

This all may sound like I am a proficient social media user – truthfully, I am lazy with it and update only when I have something worth sharing. But I am at the point now where I think word of mouth might be taking over and work comes in based on that. I feel it is important

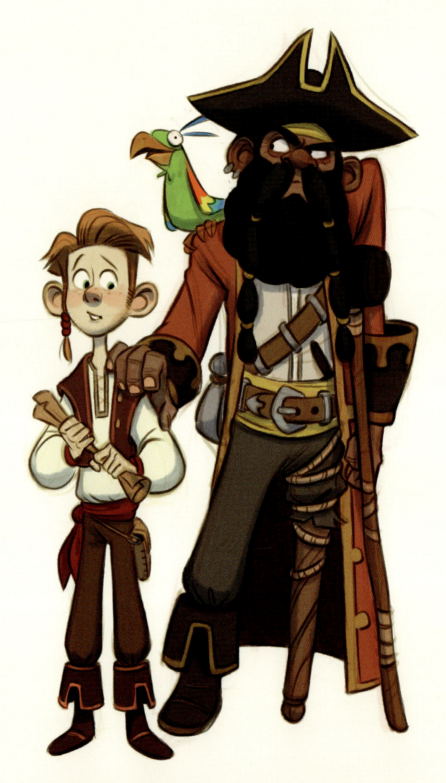

"MOST, IF NOT ALL, OF THE WORK I HAVE GOTTEN AS A FREELANCER HAS BEEN FROM PEOPLE REACHING OUT TO ME"

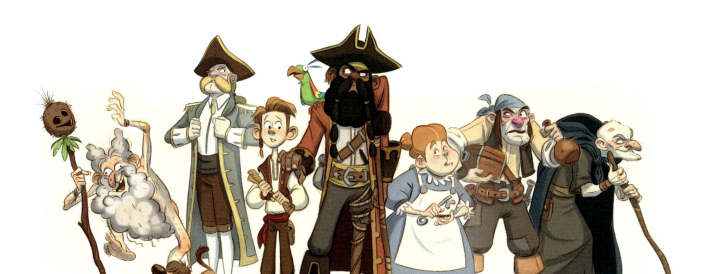

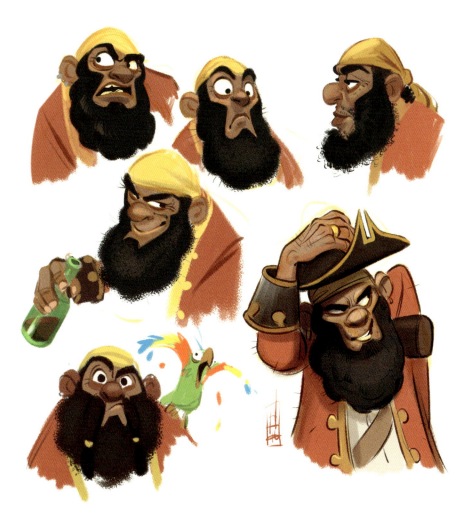

not to become too lazy though. When I go back to full-time freelancing I am sure I will need to dust off my website and social media, update them with some new work and then get back out there!

How does your background in traditional 2D animation influence the way you design characters in terms of method and style?

I'm often told that my characters are very easy to animate! I think this is because I always imagine my characters in motion and acting. I definitely try to put energy into them and don't like drawing static poses. I think also that the principles of "squash and stretch" often come out in my work. "Easy to animate" might also mean that my characters are not so simple as to be boring but not so complex they give an animator a panic attack!

My animation background also helps me with volume control, which really comes in handy when doing turnarounds or putting characters into poses. I think I have a good eye for seeing when a character goes off-model which is a skill I definitely owe to my time doing inbetweening (creating intermediary frames to make the transition from one key frame to another smoother) and clean-up on *The Illusionist*. We would spend days trying to

This page (top) and opposite: An interpretation of the characters from Robert Louis Stevenson's *Treasure Island*

This page (bottom): One of the pirates explored further in terms of design and personality

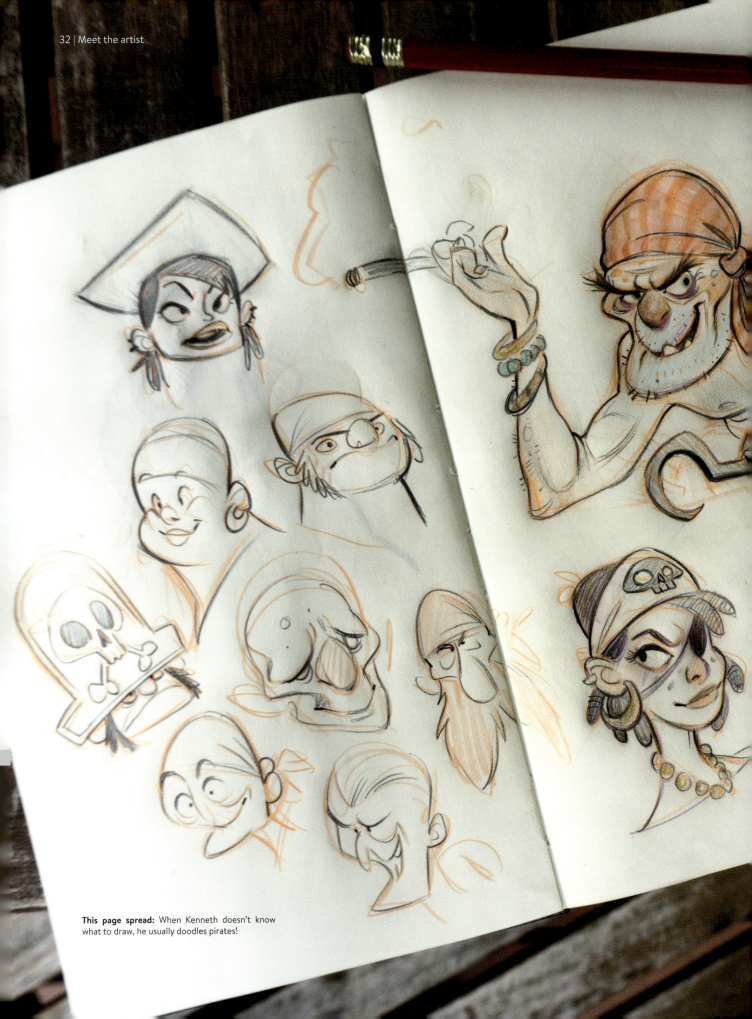

This page spread: When Kenneth doesn't know what to draw, he usually doodles pirates!

"VOLUME CONTROL IS ALSO ABOUT UNDERSTANDING THE DESIGN OF THAT HEAD, BEING ABLE TO VISUALIZE IT IN SPACE, AND THEN KNOWING HOW IT MIGHT LOOK WHEN ROTATED OR FROM A DIFFERENT PERSPECTIVE"

tame volume inconsistencies on a character as it moved! It was hard work at the time but I'm very thankful for it now. Also, as an animator I learned a whole host of other design principles such as strong silhouette, clarity, and contrast.

In terms of my method, I tend to design in the same way I used to animate. So I do a really rough sketch, trying to capture a pose or feeling, then I draw over it a bit darker and then again with a more "final" line. I tend to do this in Photoshop where I can tone down the sketch layers, but I like to keep them there to maintain that sketchy, loose feel. I think this mirrors the animation process of doing a rough drawing, doing a tie-down drawing, then doing the final clean-up drawing on top on a clean piece of paper.

For those who aren't familiar with volume control, what needs to be considered and why is it important?

Part of the task of inbetweening is studying, and then learning how to maintain the correct volumes on a character. How big is the character's head? How long are their legs? How big are their legs in relation to their head? And so on. Controlling volume ensures that these sizes and forms maintain their consistency throughout an animation.

It gets more complex however, because as soon as you turn a form in space the width might be different from the length. Foreshortening, how a form looks in perspective, also comes into play. So it isn't just about making sure that the head is the same shape and volume at all times; volume control is also about understanding the

design of that head, being able to visualize it in space, and then knowing how it might look when rotated or from a different perspective.

Working on *The Illusionist* was the best volume control training I could have asked for. Inbetweening complex characters acting in 3D space really trains the eye to see if a character is on-model or not. Now, when I take a character I have designed and draw them in a new pose, I understand the volumes and forms that make up that character and how they turn in space. In my head, as much as possible, I think of all my designs as 3D even if they are for 2D animation.

Please could you also tell us more about the "squash and stretch" principle?

"Squash and stretch" is one of the fundamental principles of animation. It basically means how a character or object squashes and stretches out as it goes though a motion. So if a character were to jump, they might squash down as they prepare to jump, and then when they are in mid-jump they might stretch out as their whole body thrusts into the air. I see it as exaggerating how things, especially organic living objects, move. It is also used to convey a sense of weight. The use of this principle can be subtle or it can be exaggerated depending on the feel you are aiming for.

The famous "nine old men" of the early days of Disney used this principle to bring life and appeal to animation. I try and bring it into my work where appropriate, though it really suits a moving image best. It is about trying to capture a key moment and selling it in a single drawing.

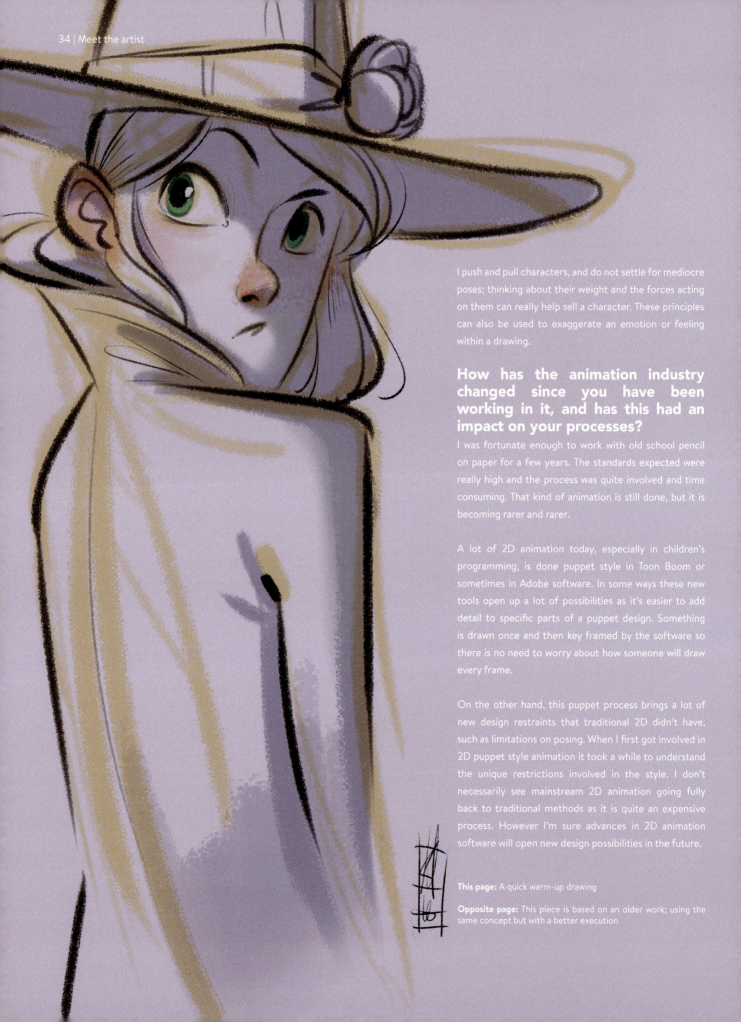

I push and pull characters, and do not settle for mediocre poses; thinking about their weight and the forces acting on them can really help sell a character. These principles can also be used to exaggerate an emotion or feeling within a drawing.

How has the animation industry changed since you have been working in it, and has this had an impact on your processes?

I was fortunate enough to work with old school pencil on paper for a few years. The standards expected were really high and the process was quite involved and time consuming. That kind of animation is still done, but it is becoming rarer and rarer.

A lot of 2D animation today, especially in children's programming, is done puppet style in Toon Boom or sometimes in Adobe software. In some ways these new tools open up a lot of possibilities as it's easier to add detail to specific parts of a puppet design. Something is drawn once and then key framed by the software so there is no need to worry about how someone will draw every frame.

On the other hand, this puppet process brings a lot of new design restraints that traditional 2D didn't have, such as limitations on posing. When I first got involved in 2D puppet style animation it took a while to understand the unique restrictions involved in the style. I don't necessarily see mainstream 2D animation going fully back to traditional methods as it is quite an expensive process. However I'm sure advances in 2D animation software will open new design possibilities in the future.

This page: A quick warm-up drawing

Opposite page: This piece is based on an older work; using the same concept but with a better execution

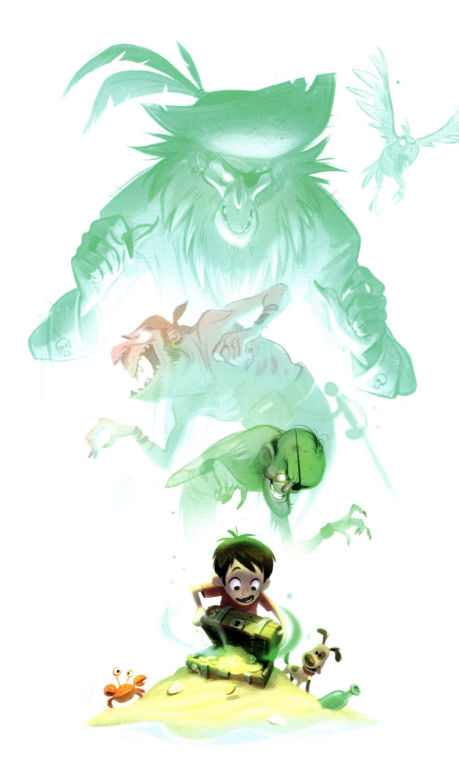

The medium does affect how I design. As a designer you are always working within the limitations of the technique and the medium. Overall, I would say 3D offers the least restriction in terms of design and it is quite common now for an animated show to be done in 3D.

Working methods aside though, the design process hasn't fundamentally changed that much. Every project has unique limitations put upon it, either from the medium it is made in, the budget, or stylistic choices. As a designer, the process is to problem solve and come up with a design which works well within the limits of a particular job.

What are the types of restrictions you encounter when designing for a puppet style animation?

My first encounter with this puppet style 2D animation was while using Adobe Flash back in art school. There are different ways to do it, but the simplest way would be to break up a character into a torso, thighs, lower legs, feet, arms, forearms, hands, and head; all the way down to eyes, mouth and other small elements. Then you put the pieces back together in a way that all the individual elements are independently movable.

This method has limitations, mainly in how the joints fit together; the arm and the hand for example must be able to sit together while looking anatomically "correct." All the joints must sit together nicely so you have to be clever with the design to make it work and some designs just aren't feasible. You also need to create the character from various angles so there are limits (especially in terms of time and budget) to how many angles you could have on a head for example.

"GOOD DESIGN IS WORKING WITHIN LIMITATIONS TO COME UP WITH SOMETHING THAT LOOKS GOOD YET STILL WORKS"

I think coming from a 2D traditional animation background, where you can draw a character in any pose and in any perspective as long as they are still on-model, makes puppet style animation feel very limiting. New software is opening up more possibilities however, and there are ways to push what's possible. In the end, design limitations shouldn't excuse bad design. Good design is working within limitations to come up with something that looks good yet still works. Sometimes having these restrictions can be a good thing!

In what ways do you find that style is important as a freelance character designer?

Often, people contact me to offer work and say that they love my style. So I guess my style is what attracts particular clients to me. I don't get people contacting me to work on dark-themed games, which is no doubt due to my kid friendly style.

So in that sense, style is important if you want to chase particular work. I enjoy drawing the way I do and I enjoy working on projects that allow me to draw in that way, so my style is my calling card in a way.

There are a lot of talented artists out there, so style is the main differentiator for catching someone's eye and getting work. I'm not sure how unique mine is; although friends have said to me they know when something has been drawn by me. I hope that's a good thing! Finding a unique style is not something I have actively pursued. It has been an unconscious evolution, narrowing in on a drawing method that I personally like.

I think adaptability is a good skill to have too. Not being too stuck in one style and having a degree of flexibility is important, especially when starting out as a freelancer. I was never a naturally talented artist from the outset; I've

had to work hard to get my work to the point where it is good enough for people to want to pay me for it. That journey involved drawing a lot of things in a lot of styles I wouldn't necessarily choose. Thankfully now, I have a lot more freedom to choose which freelance jobs I take on. This is generally down to experience, but I think also in part to the evolution of my artistic style and it's desirability as a product or service.

From another perspective, there are definitely design and style trends. Right now, there seems to be a big push towards a modern interpretation of retro children's book illustration. Personally, I try to avoid following design trends (which may be to my detriment) and instead prefer to hone a style I personally enjoy working in so I can continue enjoying it and doing my best work! I think that is what is important, and no doubt potential clients will respond to that. ♦

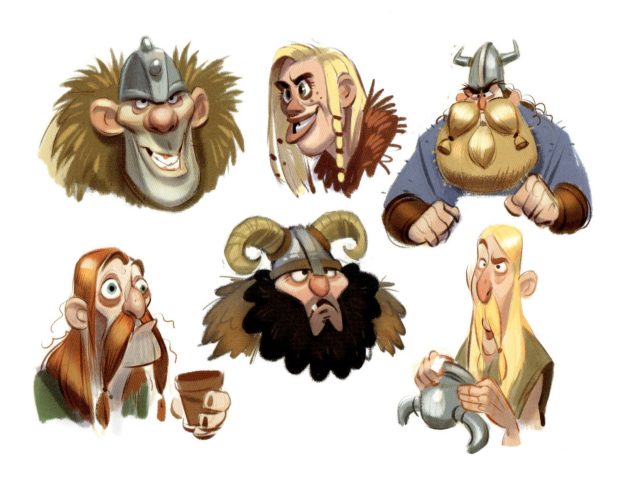

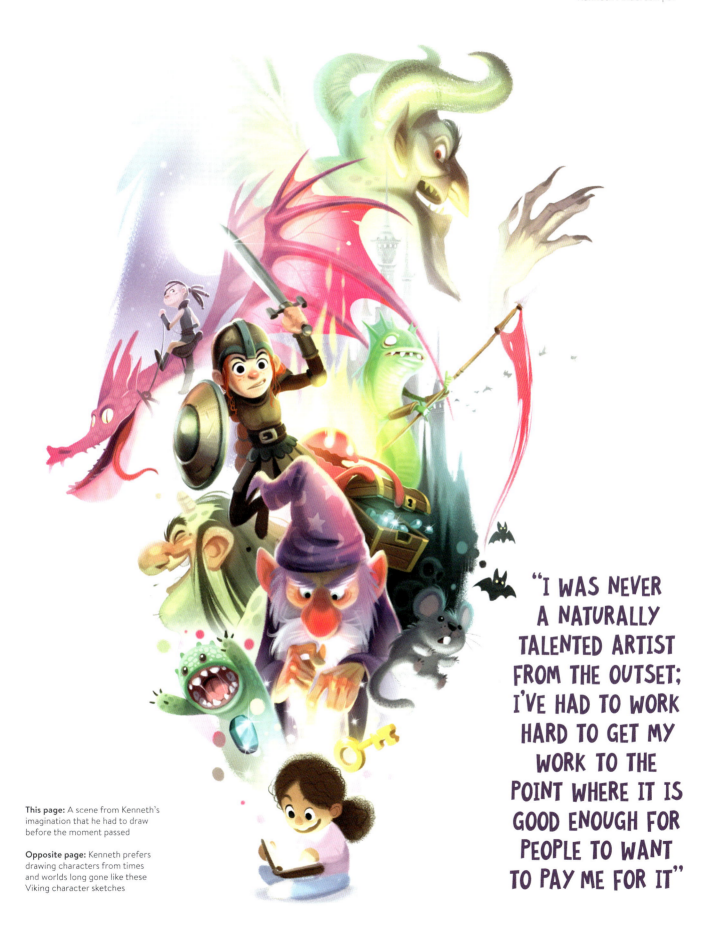

This page: A scene from Kenneth's imagination that he had to draw before the moment passed

Opposite page: Kenneth prefers drawing characters from times and worlds long gone like these Viking character sketches

"I WAS NEVER A NATURALLY TALENTED ARTIST FROM THE OUTSET; I'VE HAD TO WORK HARD TO GET MY WORK TO THE POINT WHERE IT IS GOOD ENOUGH FOR PEOPLE TO WANT TO PAY ME FOR IT"

Design children's characters

Jeff Harvey

An important part of the character designer's job is to create characters that the viewer will be able to relate to. When designing characters for a children's animation or an illustrated book however, there are special considerations a designer, as an adult, needs to make to ensure their characters are relatable to children. Children's book illustrator Jeff Harvey shares his top tips for designing characters that are understandable and appealing to a young audience.

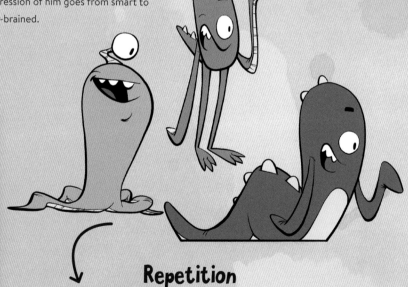

Details

Children are extremely observant so don't be afraid of adding details to your designs. This crocodile appears to be one smart guy, but a closer look shows papers are coming out of his briefcase, his tie is wonky, part of his shirt is untucked, and the pen and pencils in his pocket are askew. The impression of him goes from smart to scatter-brained.

Learn to network

Meet as many relevant people as you can. Everything I have now as an illustrator is because of who I have known and the opportunities I have taken. I introduced myself to a writer doing a book signing at Costco once and we stayed in contact. Years later he offered me a job as an art director and put me in contact with the man who would give me my first opportunity to illustrate a children's book. You will hear it a lot, but I cannot stress how important it is to build real relationships with the people in your desired field.

Repetition

Repetition of a design is incredibly important, and any good character deserves to be given this treatment. I'm always surprised at how many new ideas come out when I take the time to draw a character over and over again. Rarely do you immediately get the perfect design. Even after you think you have the perfect design, draw a few more and you may be surprised by what else comes out.

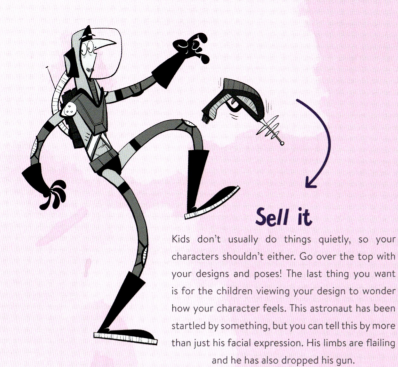

Sell it

Kids don't usually do things quietly, so your characters shouldn't either. Go over the top with your designs and poses! The last thing you want is for the children viewing your design to wonder how your character feels. This astronaut has been startled by something, but you can tell this by more than just his facial expression. His limbs are flailing and he has also dropped his gun.

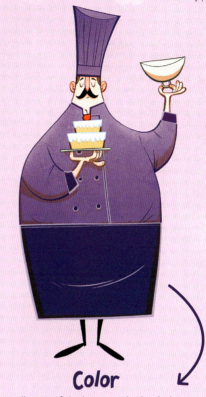

Color

This is usually one of the last steps in the design process but it is no less important. Bright colors attract children, but don't overdo it. A fun thing I like to do from time to time is take a known character, like this chef, and change the color from what is known. So in this case the character is dressed in purple hues rather than traditional whites. This creates extra interest as it encourages children to ask why he is dressed in purple instead of white like everyone else.

Use shapes

I love to use clear shapes in designs for children. Very young children often understand shapes and what they mean: circles are bouncy and fun; triangles are sharp and dangerous. For example, this guy above is made of entirely soft, rounded shapes, which basically makes him a furry ball with noodles. What's more fun and friendly than that?

Draw first, reference later

I always draw my first reactions to a design brief before I research individual elements. What does a knight's helmet look like? I don't know. Did they historically wear boots and strap shields onto their backs? No idea. But the key shapes I want are there and now I can go back and fill in my lack of knowledge with references.

All images © Jeff Harvey

GALLERY

In every issue we hope to inspire you with superb character designs and character-based artwork from a selection of talented professional artists. This issue features work by:

Greg Gunn | Basma Hosam | Guille Rancel | Alan Stewart

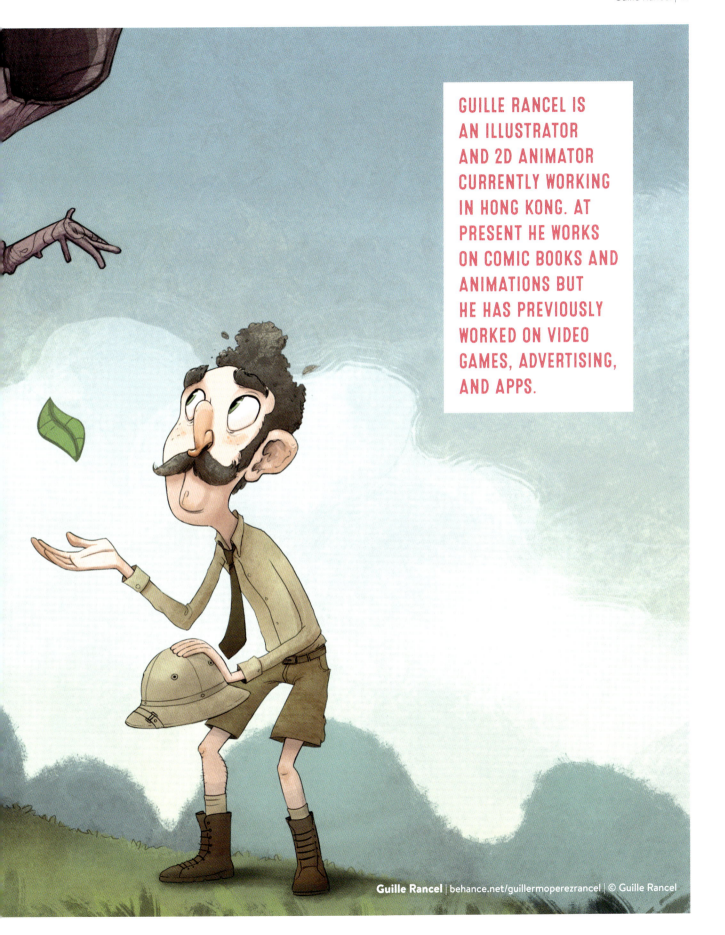

GUILLE RANCEL IS AN ILLUSTRATOR AND 2D ANIMATOR CURRENTLY WORKING IN HONG KONG. AT PRESENT HE WORKS ON COMIC BOOKS AND ANIMATIONS BUT HE HAS PREVIOUSLY WORKED ON VIDEO GAMES, ADVERTISING, AND APPS.

Guille Rancel | behance.net/guillermoperezrancel | © Guille Rancel

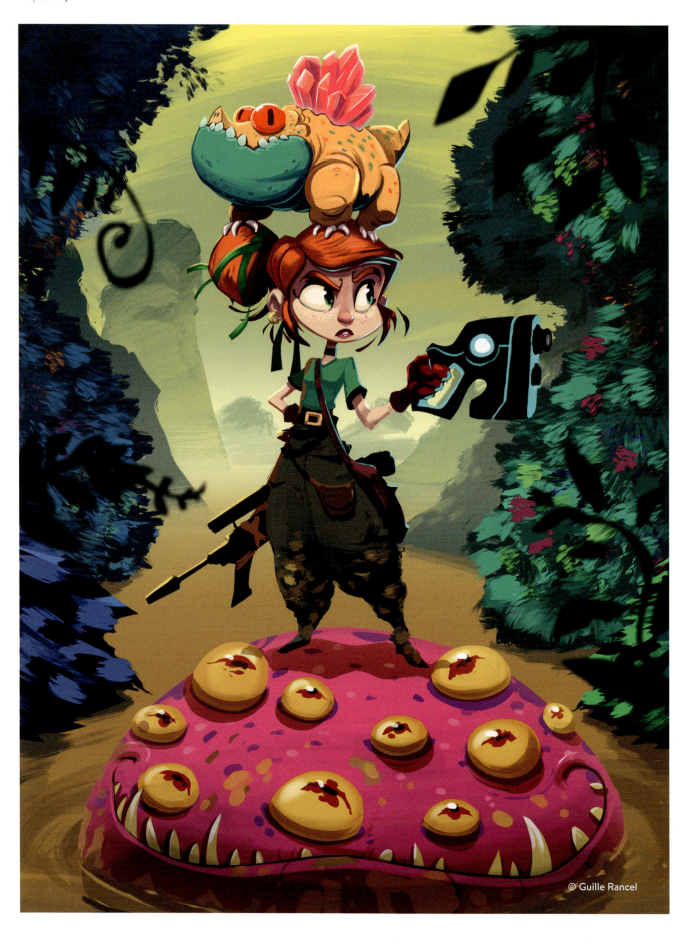

© Guille Rancel

Guille Rancel | behance.net/guillermoperezrancel | © Guille Rancel

© Basma Hosam

BASMA HOSAM IS A TWENTY-TWO-YEAR-OLD STUDYING FINE ARTS IN CAIRO, EGYPT. SHE ALSO WORKS AS A CHILDREN'S BOOK ILLUSTRATOR, WORKING FREELANCE ON PROJECTS FOR CLIENTS ALL OVER THE WORLD.

GREG GUNN IS A
LOS ANGELES-BASED
CREATIVE DIRECTOR
AND ILLUSTRATOR. AS
CREATIVE DIRECTOR
AT BLIND, HE DRAWS,
DESIGNS, ANIMATES,
AND DIRECTS
PROJECTS OF ALL
SHAPES AND SIZES.
HE IS ALSO PART
OF THE CREATIVE
EDUCATIONAL START-
UP, THE FUTUR.

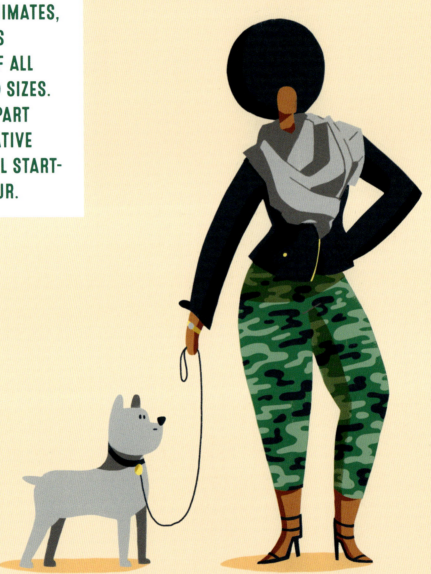

© 2018 Greg Gunn

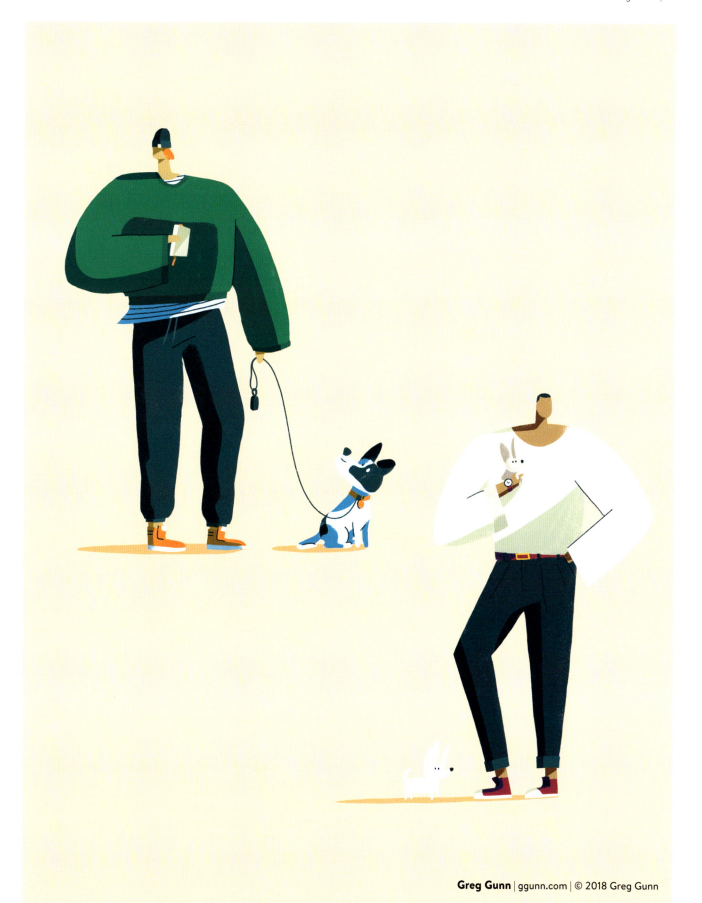

Greg Gunn | ggunn.com | © 2018 Greg Gunn

ALAN STEWART IS A CHARACTER DESIGNER FOR TELEVISION ANIMATIONS AND A PROFESSOR OF CHARACTER DESIGN. SOME OF HIS NOTABLE PROJECTS INCLUDE *WILD KRATTS*, THE NEW *MICKEY MOUSE* SHORTS, *WANDER OVER YONDER*, AND *THE LION GUARD*.

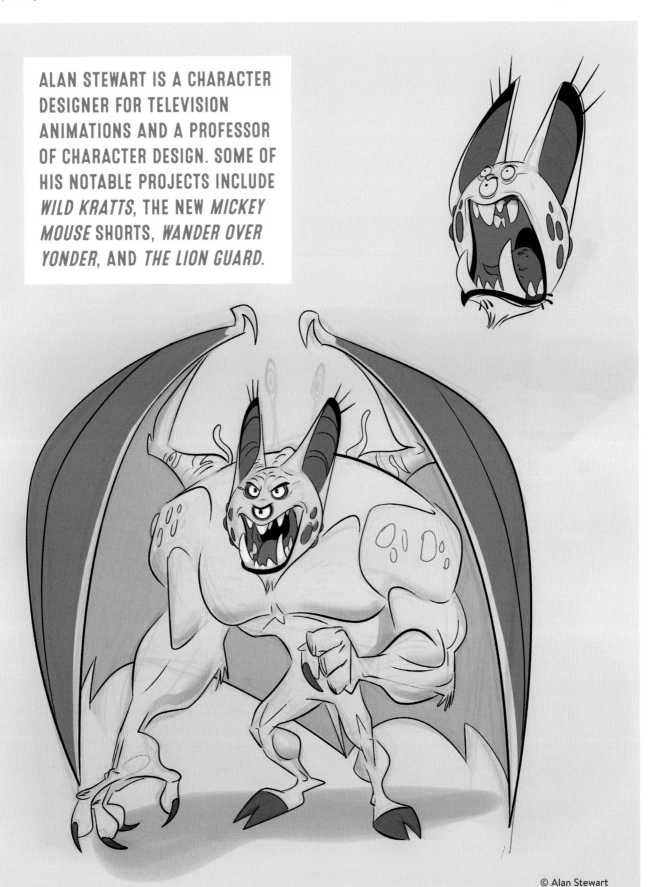

© Alan Stewart

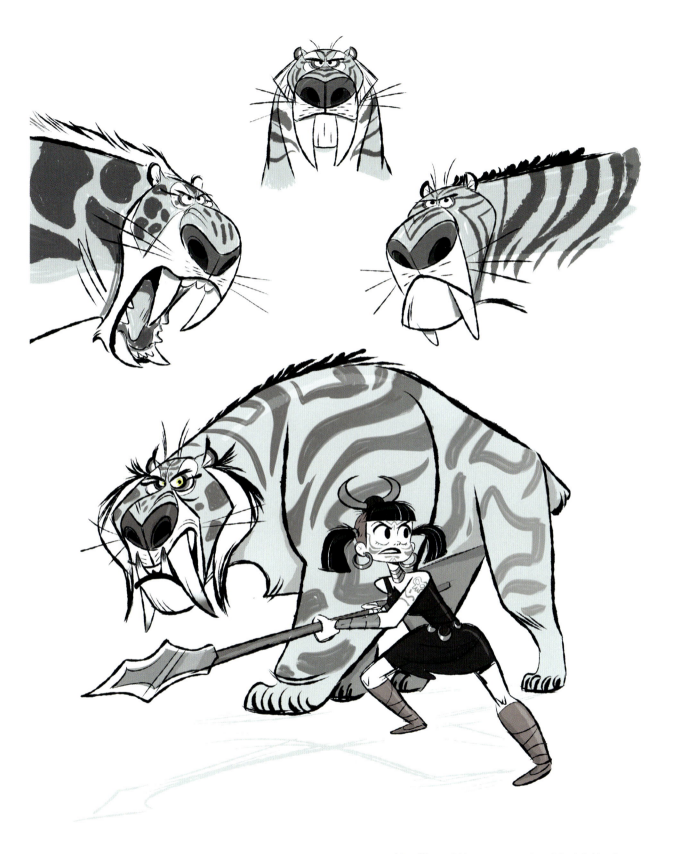

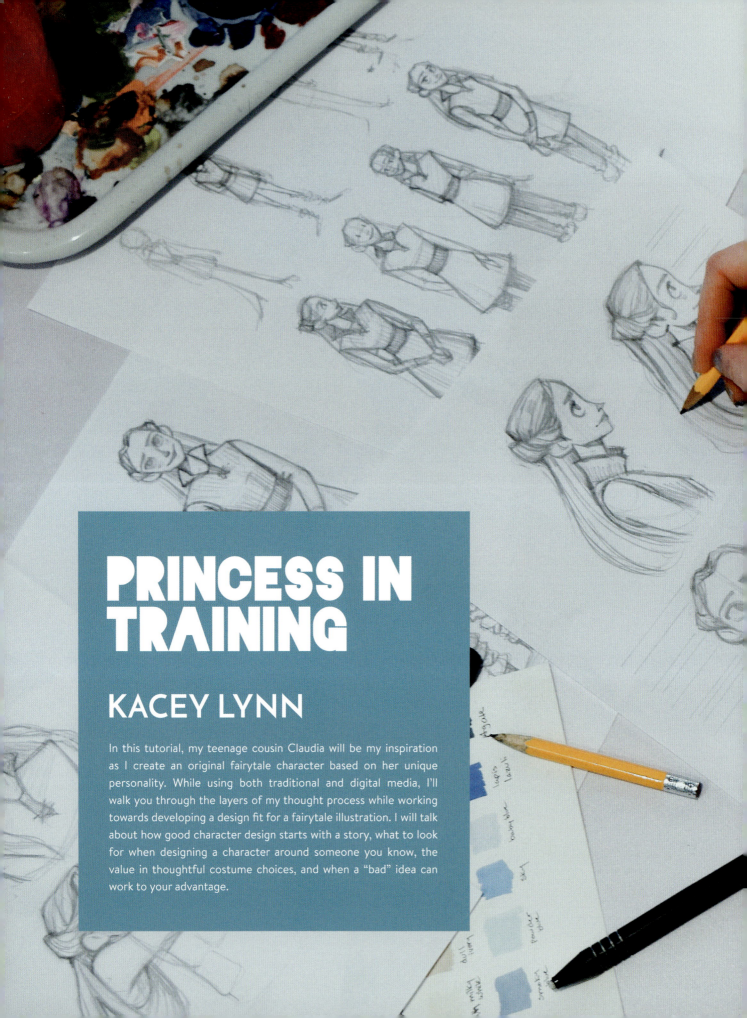

PRINCESS IN TRAINING

KACEY LYNN

In this tutorial, my teenage cousin Claudia will be my inspiration as I create an original fairytale character based on her unique personality. While using both traditional and digital media, I'll walk you through the layers of my thought process while working towards developing a design fit for a fairytale illustration. I will talk about how good character design starts with a story, what to look for when designing a character around someone you know, the value in thoughtful costume choices, and when a "bad" idea can work to your advantage.

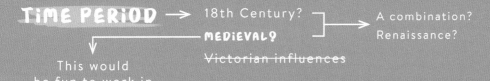

TIME PERIOD → 18th Century?
~~MEDIEVAL?~~ → A combination?
Renaissance?
~~Victorian influences~~

This would
be fun to work in

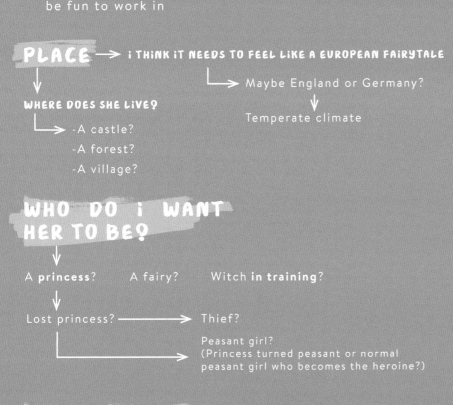

PLACE → I THINK IT NEEDS TO FEEL LIKE A EUROPEAN FAIRYTALE
→ Maybe England or Germany?
→ Temperate climate

WHERE DOES SHE LIVE?
- A castle?
- A forest?
- A village?

WHO DO I WANT HER TO BE?

A princess? A fairy? Witch **in training**?

Lost princess? ———→ Thief?

Peasant girl?
(Princess turned peasant or normal
peasant girl who becomes the heroine?)

SHE'S A PRINCESS IN TRAINING → **LIVES IN A CASTLE**

CLAUDIA

PHYSICAL ATTRIBUTES
- Gangly, long legs
- A little klutzy
- Bad posture = unsure of herself?
- Awkward teenager

PERSONALITY
A bit goofy / grumpy / moody / 100% done

Competitive
Likes to have fun ———→ playful
Passionate (only about stuff she loves) ——→ super fangirl
Shy? (sometimes)
→ awkward in her interactions

A prickly exterior, but sweet on the inside. Like a pineapple

FINDING THE FAIRYTALE

What should you consider when designing a character for a fairytale? Firstly, you need to do a little world-building before you can begin work on your character! Pick a time period and region to set your world in so that you have a solid foundation for your designs. This foundation will keep you from trying to blend too many different concepts together.

Look for inspiration and ideas for your world by watching films, reading favorite fairytales, and collecting images from the internet. All of this will help to keep the theme in the forefront of your mind when beginning to design your character.

WHO AND WHY?

Now that you have some ideas about your world, it is time to think about your character. Ask questions and invent a small backstory: who do you want this character to be in the world you have invented? What is going to be their most dominant personality trait? Do they have magical abilities? What drives them? For me, the answers are going to be influenced by who my cousin is.

I think about Claudia and write down what comes to mind. Remember, this is only the start of the process and some of your original ideas might change further along in the development process, but that is okay! Let your character be who they want to be.

Top: Your notes only need to make sense to you

Left: One thought leads to another so go with the flow!

GATHER REFERENCES

After you have finished noting the first ideas for your design, it is time to grab some photo references of your model. Have them make different expressions and take multiple poses. I talk to Claudia as I photograph her in order to get the most genuine reactions. Try to also get some candid shots which will show you how the model acts when they think the camera is off.

Take as many photos as you can, but also spend some time with whomever you are basing your character on. When using a real person to design a character, it helps to just spend time around them, observing, and taking mental notes of their quirks and individuality.

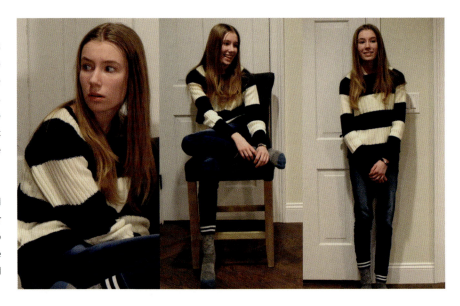

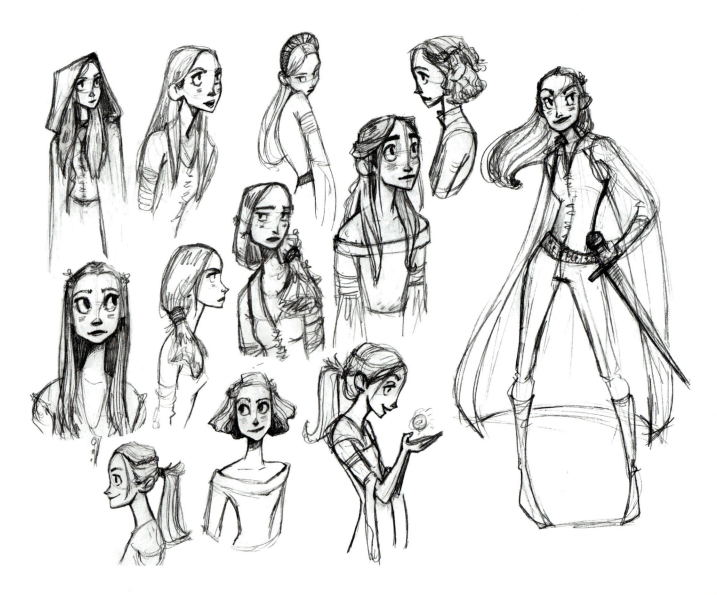

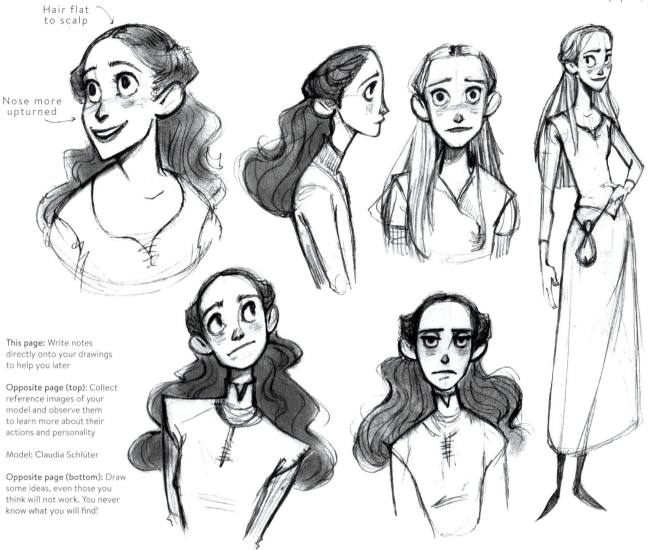

Hair flat to scalp

Nose more upturned

This page: Write notes directly onto your drawings to help you later

Opposite page (top): Collect reference images of your model and observe them to learn more about their actions and personality

Model: Claudia Schlüter

Opposite page (bottom): Draw some ideas, even those you think will not work. You never know what you will find!

START SKETCHING

Sketching is the most freeing part of the design process for me. I use the most basic materials, such as a soft pencil or a partially dried-up marker on printer paper; you do not need to use much more than that!

You can use reference photos right away to help get the creative juices flowing, or save them for later if you find they restrict your ideas. At the outset, I use only my imagination and the impressions about Claudia I have in my head. Draw some quick and messy sketches, to feel out what works and what does not. Go with your gut instinct at this point; if you see something you like, follow it!

DOMINANT TRAITS

While you sketch, think about your model's personality and what you would like to convey in your character. It would be impossible to portray every aspect of who someone is, so pick the traits that particularly stand out to you.

Claudia likes to have fun, she is passionate about the things she loves, but she can also be a bit awkward. Underneath all the bravado of being an early teen, there is a shyness about her that I want to bring out in my character.

Return once more to your backstory and see how these traits suit the story. My character is the heroine of the story, a princess in training, who is both excited and unsure about all of the responsibility in her future.

"WHEN USING A REAL PERSON TO DESIGN A CHARACTER, IT HELPS TO JUST SPEND TIME AROUND THEM, OBSERVING, AND TAKING MENTAL NOTES OF THEIR QUIRKS AND INDIVIDUALITY"

Right: Working through your unfinished, uglier ideas to see what works is the only way to get a better looking design

Below: Design decisions should be influenced by your model. Think about how they walk and stand

THE UGLY ONES

It is okay if some of your exploratory sketches are not very good (or just plain bad). If they are only readable to you and no one else at this point, that is fine. The primary objective here is to get everything out, so your brain can generate more ideas, which will lead to a more original character. If your only concern is to make something pretty, your character will not reach its full potential.

The only way to get to the pretty, finished design is to go through all the ugly, half-formed ideas first. So go ahead and make drawings that are less than satisfactory to you. Embrace the unattractive and let the process work.

ONE STEP AT A TIME

As you design your character, it is helpful to focus on only one thing at a time. For example, develop your character's personality through posture and attitude before you try to determine the other details. It can be overwhelming to try and sketch the "perfect" character with just the right pose, costume, hairstyle, facial features, and so on. The point of character design is to draw the same thing over and over again, so give yourself a break!

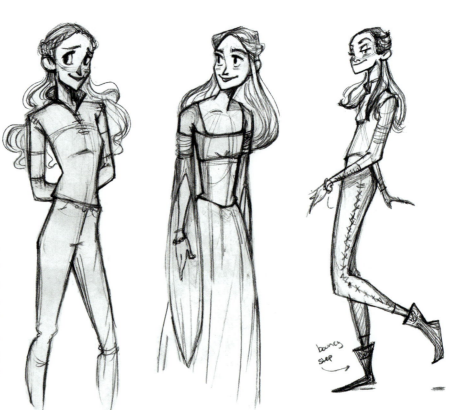

Once you have found a solid base, you can build from there. In these sketches, I want to know how she might carry herself while standing and walking, the specifics of her face and outfit still have not been decided.

NARROW iT DOWN

After all that sketching it is time for, well, more sketching! Pick one or two drawings you feel are heading in the direction you want to take your character and explore them further. I choose a portrait that I feel

captures the essence of Claudia I want for my design, and now I think more specifically about the design details, like her costume and hair.

Be intentional with the shapes you use to build your character as well. Because of the young age of my character, I do not want to use anything too curvy when defining her body type, but I do not want her to be too boxy either. The design needs to land somewhere between the two.

This page: Expand on your chosen sketch. You may like where your character is heading, but they are not there yet

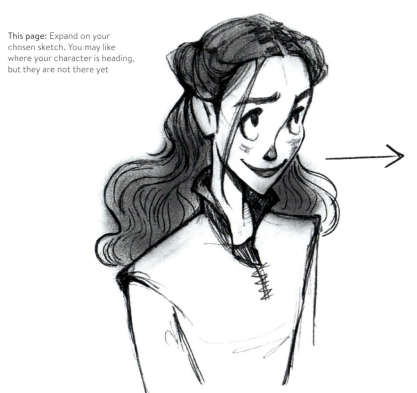

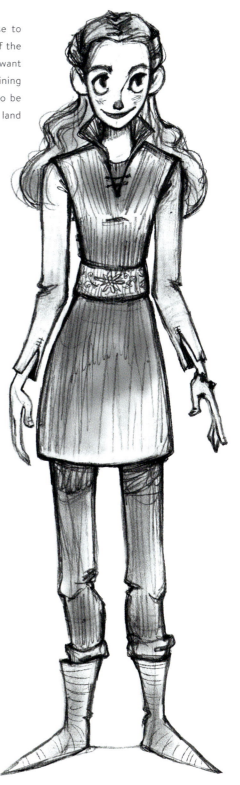

A NOTE ABOUT ANATOMY ▶

Since this character is stylized, the design is going to bend some of the rules of anatomy. The important part of anatomy for this style is that it looks believable. The only way you will be able to achieve this, however, is if you have a solid foundation of anatomical knowledge. It is vital to understand what it is you are drawing.

I suggest that you draw people from reference as often as you can, whether from photos or from life. Take a figure drawing class, read books on anatomy, and observe how people move. All of this practice will help you to become a better character designer.

"EVEN THOUGH SHE IS A PRINCESS, I FEEL LIKE SHE WOULD WEAR SOMETHING LESS RESTRICTIVE THAN A DRESS"

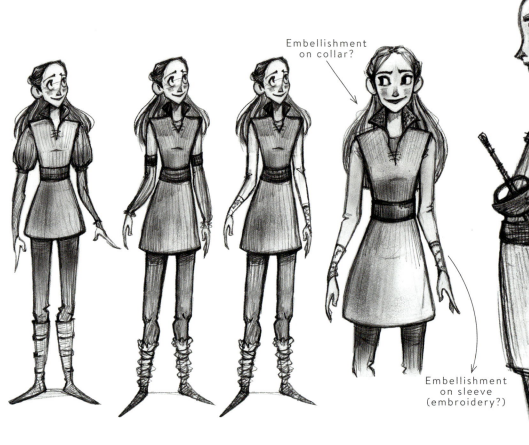

Embellishment on collar?

Embellishment on sleeve (embroidery?)

Fuzzy leg warmers to go over her boots (maybe sheepskin?)

THE COSTUME

Costumes are an essential part of any character design because they reflect your character's personality in the same way the clothes you wear reflect yours. Go back to your story notes again; the chosen time period and where your character lives should influence your design choices. Are they in a snowy climate or a tropical climate? Dress them appropriately.

My character lives in a temperate climate, and I imagine it is probably around autumn when her story starts out. I am using medieval influences, and even though she is a princess, I feel like she would wear something less restrictive than a dress. I put her in a more comfortable tunic instead.

TALK IT OUT ▶

If you are able to, it can be beneficial to talk through your design with another person. Choose someone you trust to do this; someone you know will be able to give you some good insights. Sometimes they can point out the things that are missing, or suggest what might be a good idea to change. The creative process thrives on new perspectives and after you have been immersed in the design for so long, fresh eyes are invaluable!

This page: Try multiple costume options, even if the differences are only slight

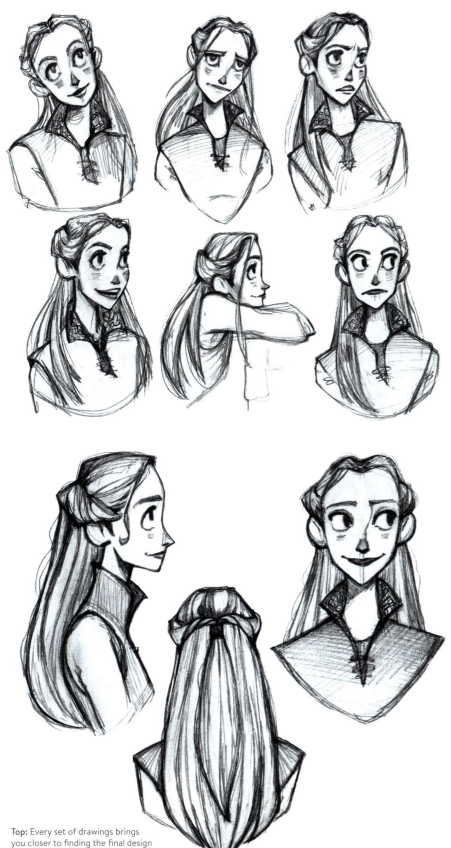

Top: Every set of drawings brings you closer to finding the final design

Bottom: In these sketches solidify what you want the character's hair and features to be

FEATURES AND EXPRESSIONS

The next step is to learn your character's features. Your reference photos are indispensable for this stage, as you will be able to see how your model's face works when they make a variety of expressions. Study your model and see what physical attributes you might want to implement into your design, such as freckles, or maybe just the shape of their eyebrows.

I love Claudia's wide smile and expressive mouth, so I put that into my character. These sketches are not the final versions of her expressions, just a way to learn. The more you draw your character, the more you understand who they are, so draw, draw, and draw some more!

HAIR

We have made it to my favorite part of a design: the hair! Hairstyles, like costumes, reinforce your character's identity. For my design, I go for a simple style that will keep her hair out of her face as she goes about her daily routine. It is also a style she could do herself, which I think suits her because I cannot see her wanting someone else to do her hair for her in the morning.

After you have established the final hair design, make a reference sheet of your character's hairstyle and features. This is especially useful if you are illustrating a book as it will help you draw consistently throughout the story.

> "HAIRSTYLES, LIKE COSTUMES, REINFORCE YOUR CHARACTER'S IDENTITY. FOR MY DESIGN, I GO FOR A SIMPLE STYLE THAT WILL KEEP HER HAIR OUT OF HER FACE"

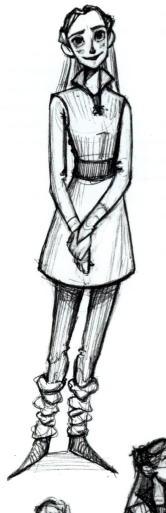

PUT iT ALL TOGETHER

It is time to create your final character illustration! Use the "one step at a time" idea again, to first find out what pose will best present the character to your audience. Sketch out a few small thumbnails. As you have done throughout this process, think about what will suit your character. How would they react if they were suddenly put on the spot for a picture? Or in my character's case, a portrait painting? Body language is very telling of both the character's personality and their story. I want to do something that shows how my character feels slightly uncomfortable, but knows she needs to pose anyway. I opt for a closed body position.

PICKING THE PALETTE

Once you decide on a pose you can begin to think about the additional details that will support your design. The most significant of these is the color palette you use. Experiment with some different options and try multiple color combinations. Consider complementary colors (purple and yellow, red and green, orange and blue, and so on), as well as palettes that use different saturations and values of the same color.

There is an emotional element to how people experience and relate to colors too. If your character is more reserved for example, the chances are they will not be running around in a neon orange outfit because they would not want to attract too much attention.

This page: Push yourself to keep drawing the pose until it is right. When your sketch is finished, it is time to start thinking about color!

Opposite page: Try out a variety of color palette options to see what fits the character

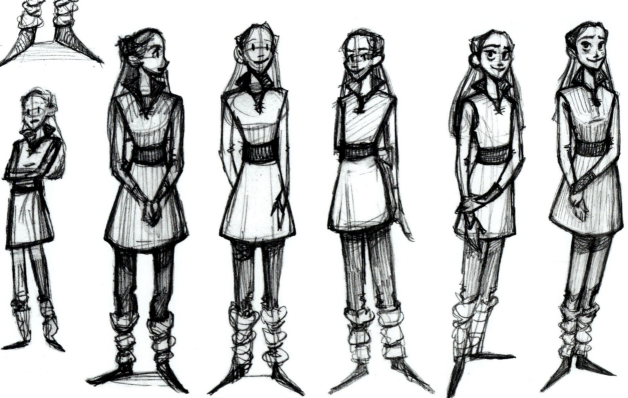

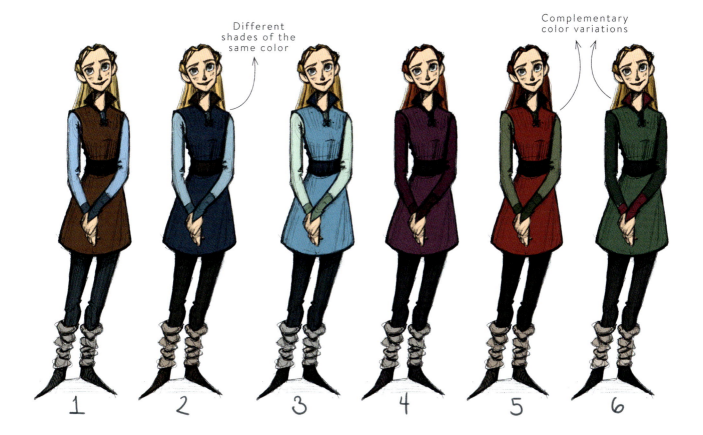

Different
shades of the
same color

Complementary
color variations

1 2 3 4 5 6

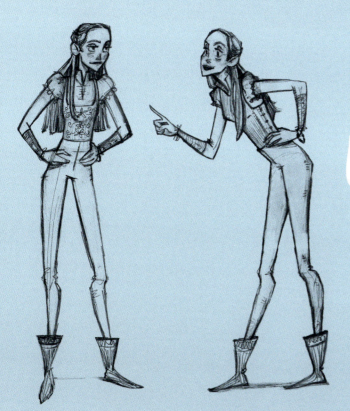

Above: If it is not quite working, scrap it, even if you like certain elements

iDEAS TRASH CAN

I start to follow this design, but something does not feeling right. She is heading in a direction that strays from my original thoughts and looks too harsh and sassy. She is not reaching the level of appeal and relatability that I want.

If you find this happening while designing, do not sweat it! It can sometimes work to your advantage if you know what you do not want in a design. You can move forward from there with a clearer insight of where you want to be.

PAINT iT UP

My first inclination is to go with color palette one, with the brown tunic, as it seems right to me. But I realize that I am gravitating towards it because it looks like something I have already seen a fairytale heroine wear. Instead, I choose option three; I like the blues and greens, as well as what is happening on the value scale.

As you paint and finalize your design, remember to keep track of where your light source is and pay attention to the extra details you can add. I know I want some embellishment on her sleeves, so I research medieval textile patterns and use them as inspiration to create my own. Tiny details can make a great difference.

THE FLUiDiTY OF PROCESS

Do not forget that the character design process is just that: a process. When developing anything, you will find yourself going back and repeating steps until you arrive at what you want. Maybe you will even end up scrapping the whole thing and starting over because the concept is just not working. You can use these steps as a guide to get yourself going, but know that it ultimately depends on you as an artist. There will be many times when your process changes for each character you design, but that is part of the fun! Find what works for you and then give it all you have got!

Above: The difference between the lightest and darkest values is pleasingly not too extreme with this palette

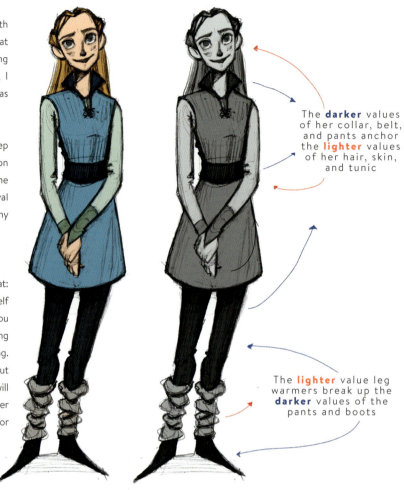

The **darker** values of her collar, belt, and pants anchor the **lighter** values of her hair, skin, and tunic

The **lighter** value leg warmers break up the **darker** values of the pants and boots

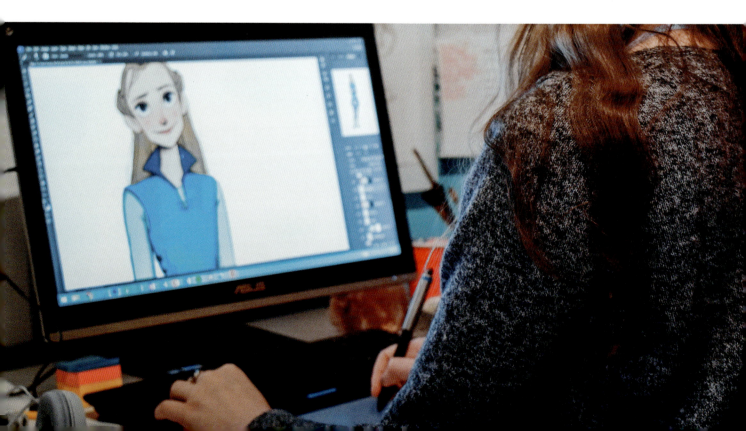

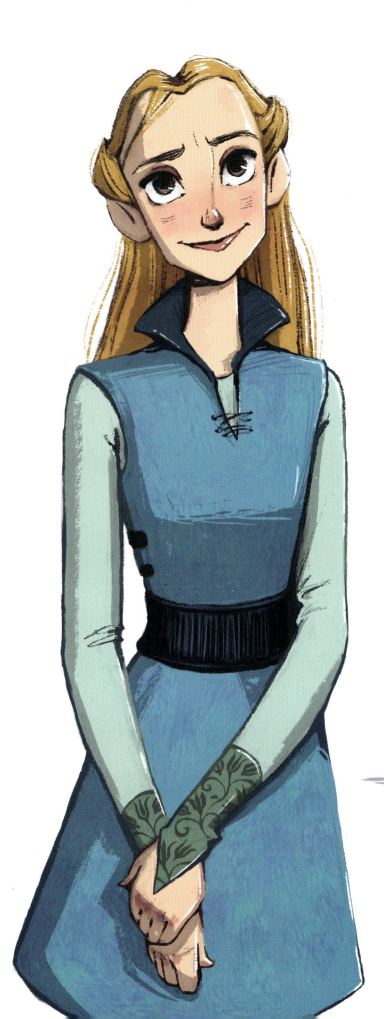

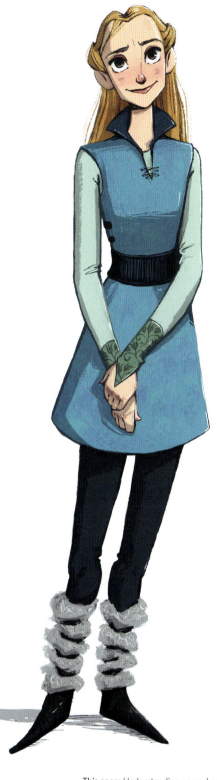

This page: Understanding your character from the inside out will give heart to your design

All images © Kacey Lynn

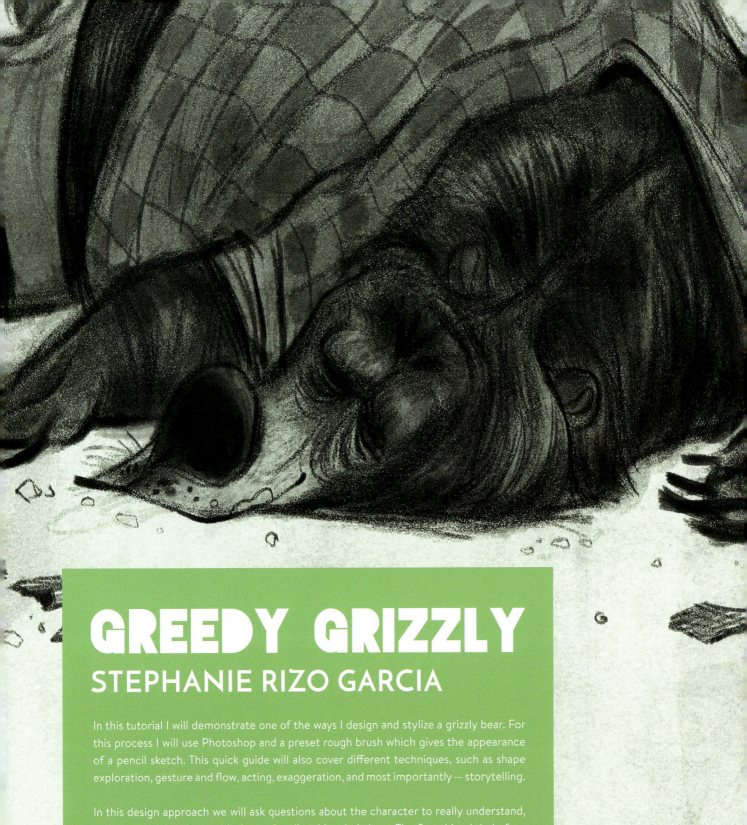

GREEDY GRIZZLY

STEPHANIE RIZO GARCIA

In this tutorial I will demonstrate one of the ways I design and stylize a grizzly bear. For this process I will use Photoshop and a preset rough brush which gives the appearance of a pencil sketch. This quick guide will also cover different techniques, such as shape exploration, gesture and flow, acting, exaggeration, and most importantly — storytelling.

In this design approach we will ask questions about the character to really understand, and narrow down, how to design and stylize this grizzly bear. The first thing I do before I even start sketching is to make a small list which answers the "who" and "what" questions. When finished, I am ready to design an old bear that has eaten too many blueberry muffins!

Simple shapes

This page: Simple abstract shapes can form the base of initial loose sketches

SHAPE

When first exploring a design for a character I like to play around with the shapes that will form the base of the design. For an animal character, begin by looking up a lot of references on how the animal is constructed and study its shapes. For this article I am designing a bear, so I want to focus on how much I can exaggerate the basic shapes that signify he is a bear, such as the large body mass and rounded ears.

Once you have a clear idea of the shapes that need to be emphasized, create thumbnail sketches based on the different shapes. Working to this small scale will help avoid thinking about the details of the character at first, and instead focus on how these abstract shapes can best describe a possible pose.

This bear is sluggish and tired from eating all of those muffins, so I create big blobby shapes that are low to the ground, as if gravity is pulling them down. By comparison, if you were to create a happy or alert character you would need to create shapes that were much lighter, and standing or sitting upright.

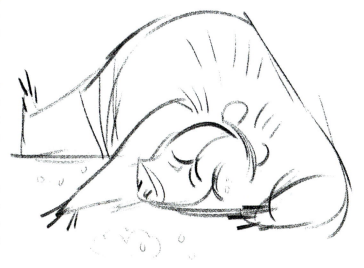

ROUGH SKETCH

Once a few possible poses have been loosely sketched out, choose a shape to sketch over. I chose a shape with a big arc that really emphasizes how big and heavy the bear is. The sloping sides suggest he has slumped to the ground and is sleepy.

Remember to continue emphasizing the character's personality through the pose in the rough sketch. The splayed pose of this bear, with the neck slightly turned to the side, and his arms and legs wide open, show he is too tired to move around. While creating these shapes, it is important to be conscious of how they work within a complete framework.

"THE EYES ARE PINCHED TOGETHER TO GIVE THE EFFECT OF THE BEAR FEELING VERY TIRED AND ALSO SHOW THAT HE IS AN OLD BEAR"

FLOW AND ENERGY

In this step, make sure that the character design has flow and a sense of energy through the line work. As you can see by the green arrows on my sketch below, there is a flow towards the face creating a focal point where we can see their expressions. The red arrows below indicate the flow of energy coming up and out through the back.

It is important to make sure that a design has flow to be able to clearly read how the character is feeling. I like to create lines that really push the gesture and energy of the bear, so I make lines to highlight that he is lying down, showing that his body is grounded.

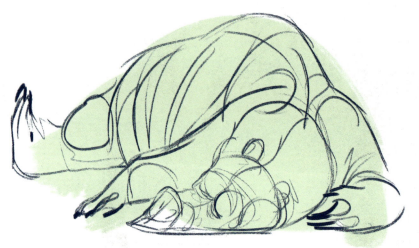

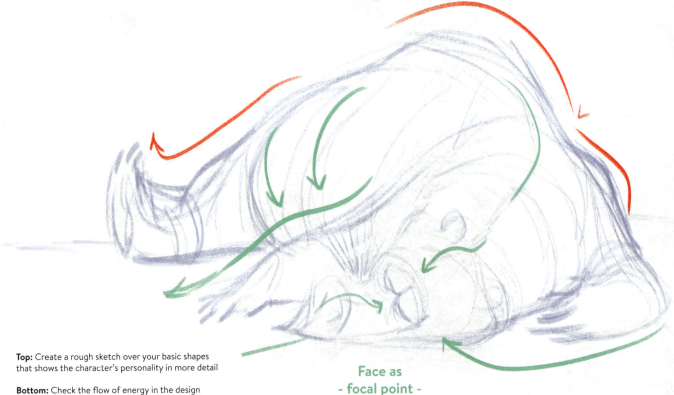

Face as
- focal point -

Top: Create a rough sketch over your basic shapes that shows the character's personality in more detail

Bottom: Check the flow of energy in the design

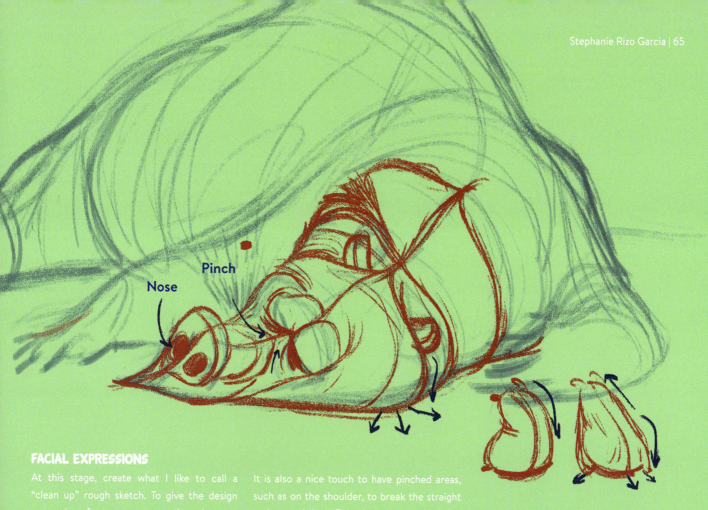

Nose

Pinch

FACIAL EXPRESSIONS

At this stage, create what I like to call a "clean up" rough sketch. To give the design expression, focus on exaggerating elements of the design, especially in the face. The eyes are pinched together to give the effect the bear is feeling very tired, and also shows that he is an old bear. I design the nose a bit bigger than usual to best describe the character, and to give the feeling that he is friendlier than the average bear.

In the corner of my sketch I quickly draw a couple of bear-like bags to explore how the weight of the bear's neck creates a curve. I compare the shape of the curved bag to a bag that is also heavy, but does not show the gesture as clearly as the first. This allows me to improve the gesture of the bear's neck, and emphasize the heavy feeling.

RHYTHM

Moving along the rest of the bear's body, make sure that the sense of rhythmic motion in the character is clear. The blue arrows I have drawn over the rough cleaned-up sketch (right) show a mix of straight and curved lines in the design to help to create a clear rhythm.

It is also a nice touch to have pinched areas, such as on the shoulder, to break the straight and curved lines. This gives an energy in the character's gesture, and shows how heavy his body is, and how his weight affects those other curves around his body. It helps again to confirm that the character is grounded and not simply weightless.

Above: Focus on exaggerating facial expressions that help to show the character's personality

Below: Assess whether there is a sense of rhythm in the design and add pinched areas for interest

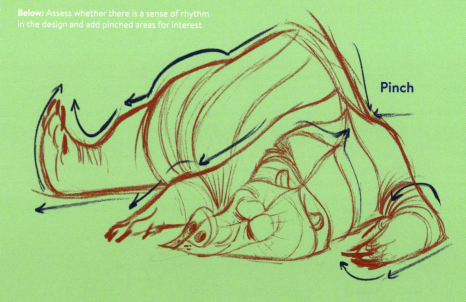

Pinch

"I LIKE TO GIVE IT A BRUSH-LIKE TEXTURE AS THIS CREATES ENERGY IN THE FINAL VERSION"

LOOSE AND DETAIL

In this final step we get to add life to the character. I choose to dress the bear in a plaid pajama suit because he is a sleepy old bear. With a set of pajama clothes there is a better sense that he has just had a late night snack and eaten too many muffins. I then add a few muffins around the bear to show how much he has eaten, and to illustrate the story of his binge on blueberry muffins.

When I clean up a final design I like to give it a brush-like texture as this creates energy in the final version. I keep the lines flowing in the same direction as the shape they cover, to preserve the volume of the body, and also to give it a soft texture that shows the bear is soft and silky.

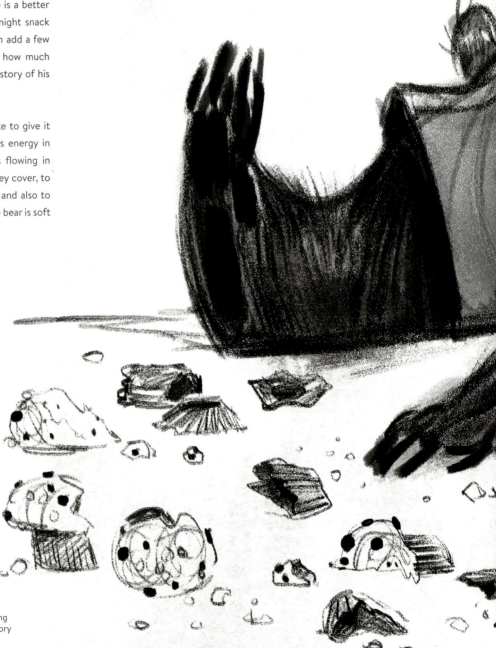

This spread: Finalize the design by adding details and textures that support the story

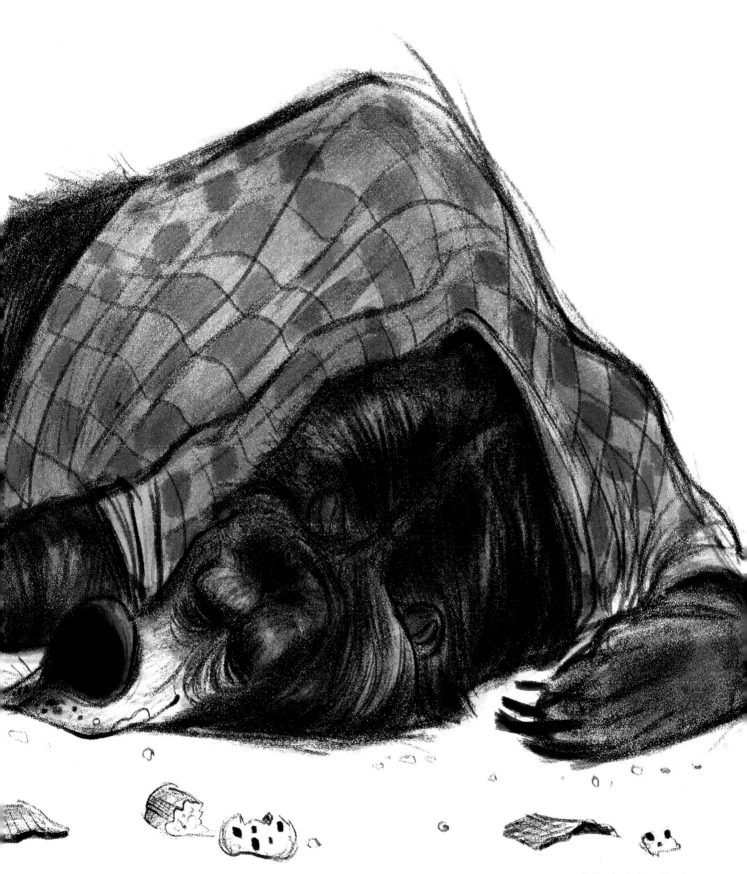

© Stephanie Rizo Garcia

MEET THE ARTIST:
Karoline Pietrowski

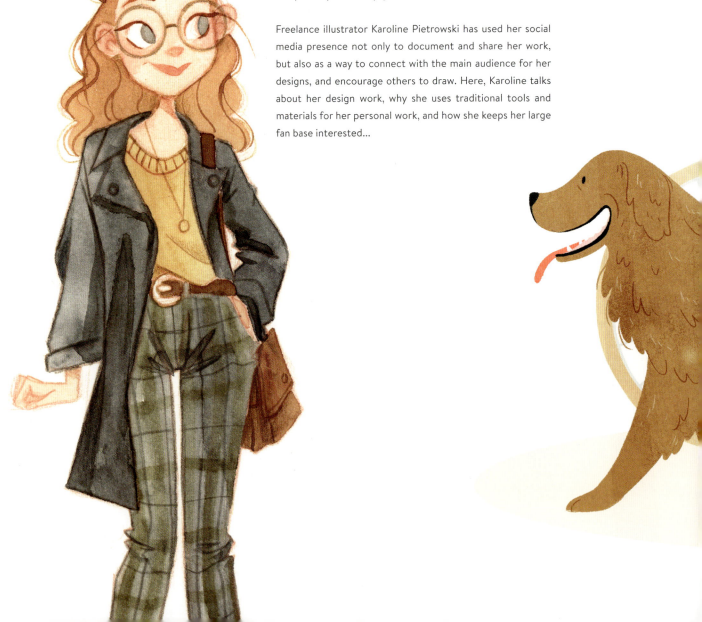

Putting your creative work online can often feel like a risk; it involves making a public statement about who you are as an artist or designer, and offers your work up to the criticism of strangers. Yet there are also many benefits to showing your work. It can build confidence as an artist, pin-point areas for improvement, help network and make new friends, and possibly even help generate a new income.

Freelance illustrator Karoline Pietrowski has used her social media presence not only to document and share her work, but also as a way to connect with the main audience for her designs, and encourage others to draw. Here, Karoline talks about her design work, why she uses traditional tools and materials for her personal work, and how she keeps her large fan base interested...

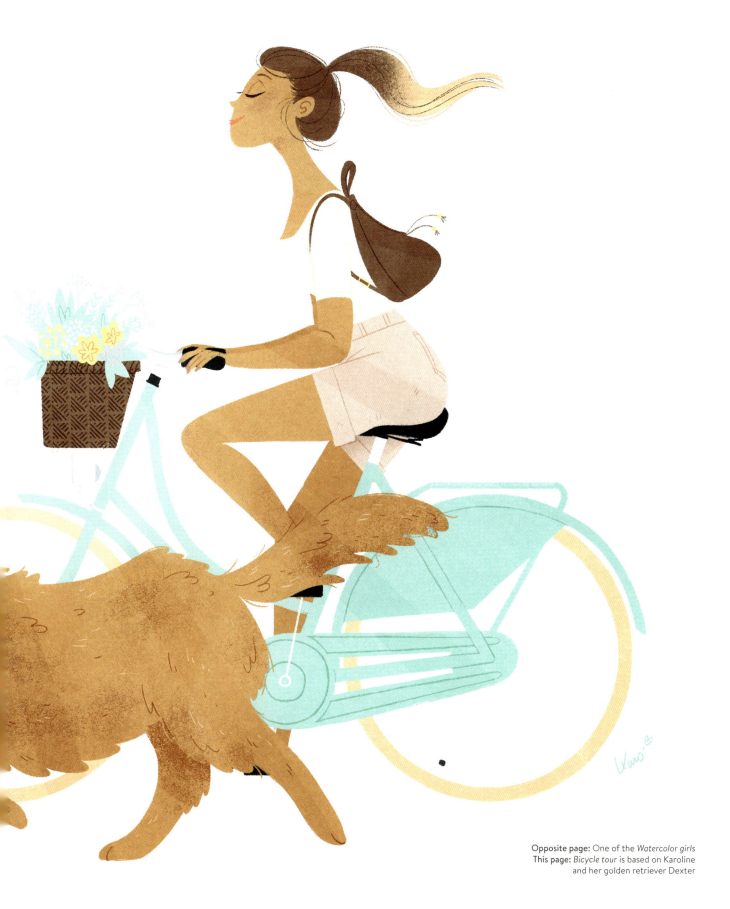

Opposite page: One of the *Watercolor girls*
This page: *Bicycle tour* is based on Karoline
and her golden retriever Dexter

All images © Karoline Pietrowski

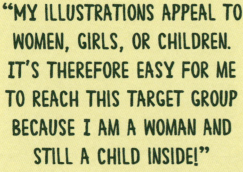

"MY ILLUSTRATIONS APPEAL TO WOMEN, GIRLS, OR CHILDREN. IT'S THEREFORE EASY FOR ME TO REACH THIS TARGET GROUP BECAUSE I AM A WOMAN AND STILL A CHILD INSIDE!"

THANKS SO MUCH FOR LETTING US FIND OUT MORE ABOUT YOU! PLEASE CAN YOU TELL US A LITTLE BIT ABOUT YOURSELF AND YOUR ART BACKGROUND?

When I was young, drawing was one of my greatest hobbies. I started drawing Manga comics at an early age and even then I wanted to be "famous" for my drawings. I was inspired by different anime series, video games, and also Disney movies. When I grew older I started my creative career with a degree in communication design in Düsseldorf, Germany. At first, I mainly focused on photography. However, I quickly came back to illustration because of the many inspiring people I met at that time. During my studies, I started my career as a freelance illustrator and I continue that freelance career today.

This page: *Italian girl*

Opposite page (left): A character from the *Watercolor girls* series

Opposite page (right): Karoline loves to paint in watercolor as it is so relaxing

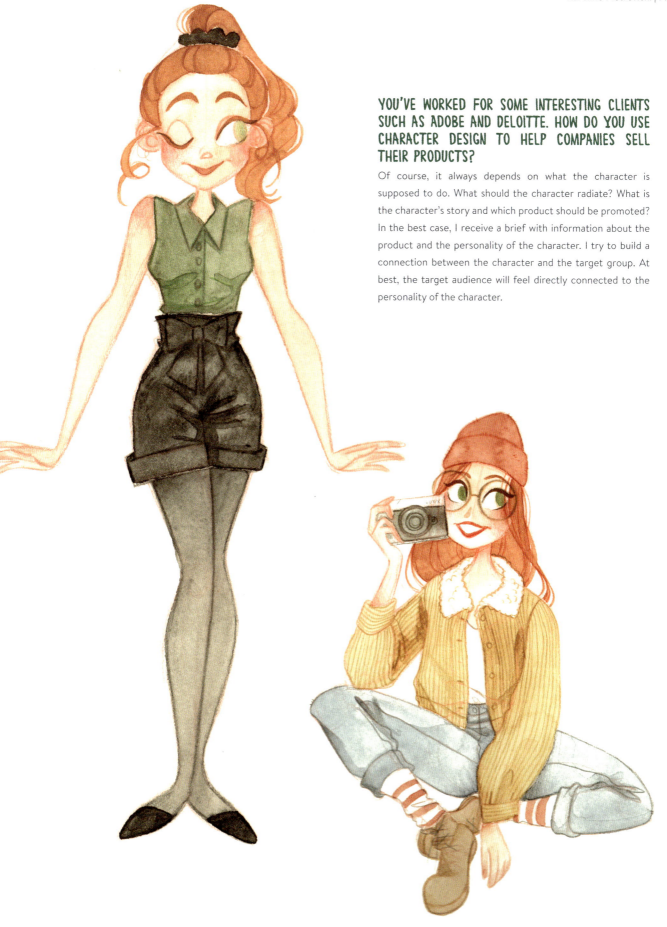

YOU'VE WORKED FOR SOME INTERESTING CLIENTS SUCH AS ADOBE AND DELOITTE. HOW DO YOU USE CHARACTER DESIGN TO HELP COMPANIES SELL THEIR PRODUCTS?

Of course, it always depends on what the character is supposed to do. What should the character radiate? What is the character's story and which product should be promoted? In the best case, I receive a brief with information about the product and the personality of the character. I try to build a connection between the character and the target group. At best, the target audience will feel directly connected to the personality of the character.

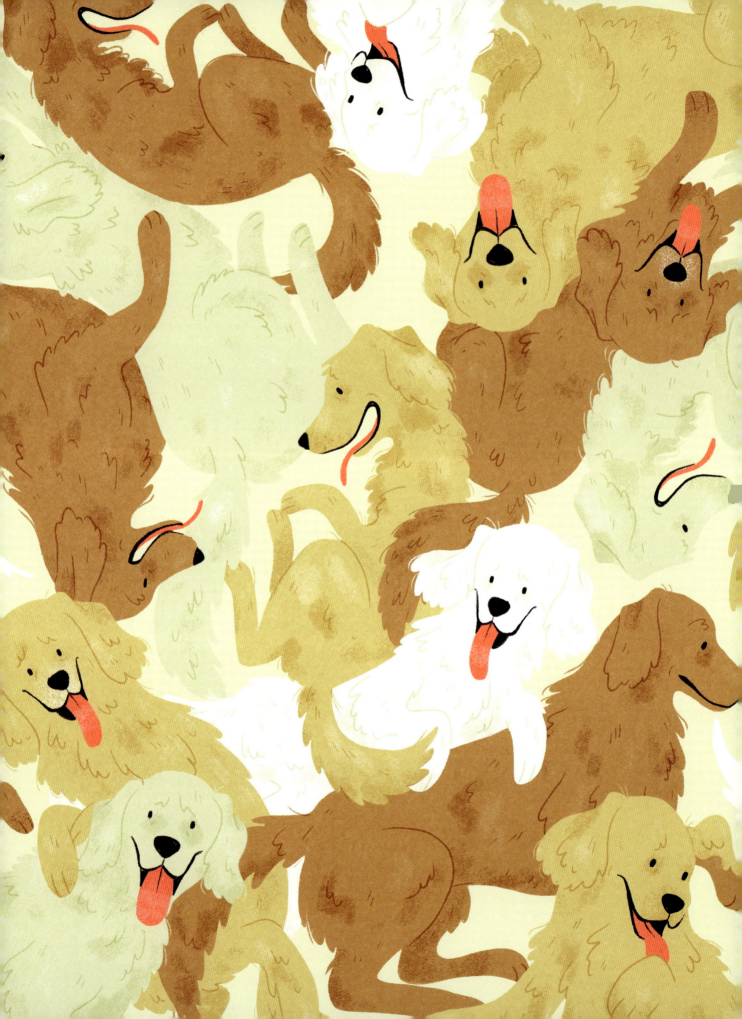

> "INSTAGRAM STORIES AND SURVEYS ARE A GREAT WAY TO FIND OUT WHAT MY FOLLOWERS LIKE AND WHAT THEY ARE NOT AS INTERESTED IN"

THAT'S A REALLY INTERESTING APPROACH. IN YOUR EXPERIENCE WHAT ARE THE BEST METHODS TO HELP YOUR TARGET AUDIENCE FEEL CONNECTED TO THE CHARACTER? HOW DID YOU BUILD UP YOUR AUDIENCE?

First of all it is important to know, or get to know, your target group. In the best case scenario I know the target group for a character or someone who belongs to it. In most cases my illustrations appeal to women, girls, or children. It's therefore easy for me to reach this target group because I am a woman and still a child inside! But I also like to ask my family and friends for their opinions on my characters.

I ask my audience directly what they like. Instagram stories and surveys are a great way to find out what my followers like and what they are not as interested in. It is important for me to know what my fan base wants to see so that the audience continues to grow.

At the same time though you should always be yourself and should not pretend to be interested in themes or styles just to please your followers. It is important to do what you like so that you do not lose the fun of sharing on Instagram.

This page: *Pandora*

Opposite page: *Golden Retriever* is inspired by Karoline's dog Dexter

> ## "FOR CLIENTS I OFTEN DEVELOP CHARACTERS THAT ARE FOLLOWING A SPECIFIC GOAL. THIS GOAL MUST BE CLEAR TO THE CUSTOMER AT FIRST SIGHT"

HOW DID YOU BUILD UP AN AUDIENCE YOU COULD SELL YOUR WORK TO ON ETSY? HOW DO YOU BALANCE THIS WITH YOUR FREELANCE WORK?

For clients, I mainly work digitally. In my free time, however, I work on traditional drawings and illustrations that pile up in my drawers. I scan them for my archive and then don't know what to do with all the sketches and illustrations, so I like to give pleasure to those who enjoy my work by selling them. The audience tends to know my personal work from Instagram and tracks my progress there. If they like an illustration or a sketch they can buy it on Etsy.

I do not spend as much time working on my shop as some illustrators do. I know many other illustrators who invest a few hours every week in their shop but that does not apply to me. My aim for the shop is to delight my audience by enabling them to purchase one of my original drawings and of course, I try to take pretty photos and to package the shipment lovingly. I do not create any merchandise such as stickers, stamps, postcards, and so on because I do not have the time to cultivate my shop so intensely.

WE CAN SEE THAT FOR YOUR PERSONAL WORK YOU USE TRADITIONAL TOOLS A LOT. WHAT MAKES YOU CHOOSE THESE OVER DIGITAL MEDIA IN THESE CASES?

Traditional tools help me to relax. I like to draw and scribble no matter when or where. All I need is a piece of paper and a pen. This is also the easiest way for me to put my spontaneous ideas on paper. In addition, I love to try different papers and materials; watercolor especially pleases me. I am not a professional in watercolor painting but I like to experiment, make mistakes, and try out different techniques.

WHAT DIFFERENT DESIGN PROCESSES DO YOU USE WHEN WORKING PROFESSIONALLY OR FOR YOURSELF? WHAT IS YOUR FAVORITE ASPECT OF THE PROCESS?

For clients I will often develop characters that are following a specific goal. This goal must be clear to the customer at first sight in order for the design to be successful. When I am creating for myself however, I develop characters whose story may not be immediately clear. My own characters leave room for the viewer's imagination and for different story interpretations.

My favorite part of designing a character is definitely shape language! I love to explain an idea with different shapes and sizes. Sometimes I lose myself in this process so that a story automatically develops around it. Colors also play a role for me but I often try to use them more discreetly. ♦

Opposite page: *French girl*

Right: A sketch from the *Watercolor girls* series

Below: Karoline's workspace

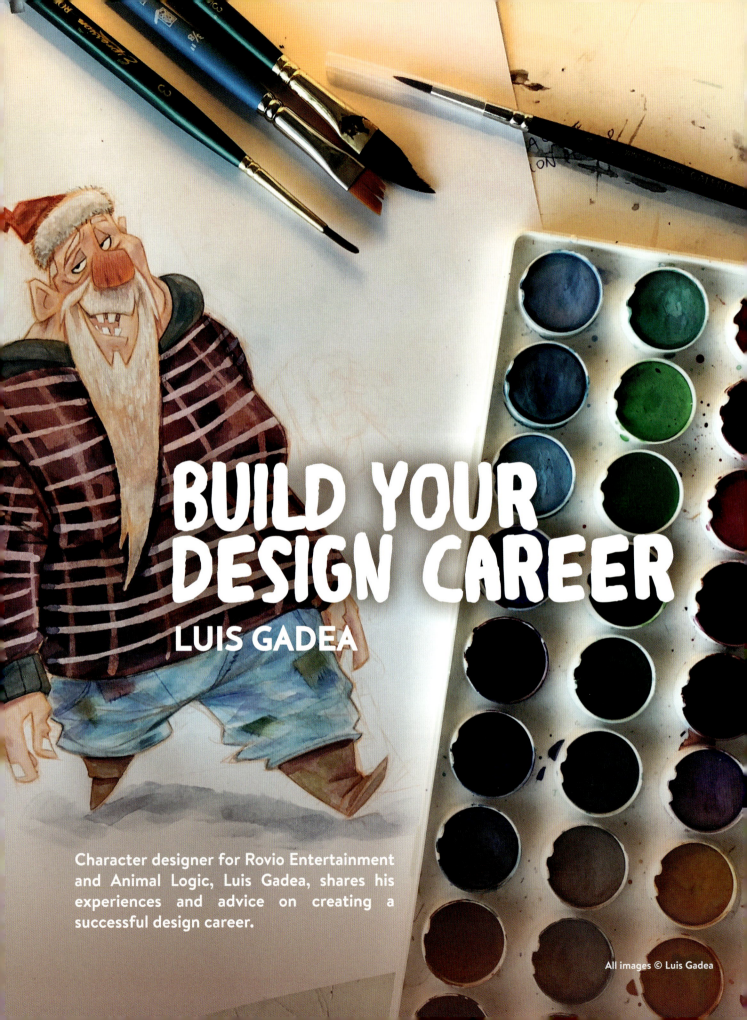

BUILD YOUR DESIGN CAREER

LUIS GADEA

Character designer for Rovio Entertainment and Animal Logic, Luis Gadea, shares his experiences and advice on creating a successful design career.

All images © Luis Gadea

My story as a character designer is a long one: I started studying 3D animation back in Costa Rica and while studying I found I always had more fun working on the preproduction side of animation. I would spend more time drawing than sitting in front of a computer. Then my first job in the industry was at a studio doing 2D animation. I had no idea really how to do it, but they trained me and because of this I decided I wanted to study 2D animation instead.

I moved to Vancouver and graduated from a classical animation program at Vancouver Film School. It was a great experience because I got to just draw for the entire program. My first job after graduation was working as a 2D animator on the Canadian TV series *Rocket Monkeys*, and in my free time I posted character designs on my blog. Every single day I drew ideas of my own and kept practicing different styles.

I then worked as a storyboard artist on the animated Marvel *Avengers Assemble* TV series. And again, in my spare time, I kept practicing and drawing characters because that was my true passion. During every work break I would try to design something new, and through this practice I kept learning.

After a few other professional positions and projects I became an animation director on season two of *Rocket Monkeys*. A few months in to that role however, I got a call offering me a position as a character designer on *The Angry Birds Movie*. I asked the recruiter how they found me and she said they had found my blog; so it just goes to show that all the extra hours I spent drawing for my own happiness had paid off.

Opposite page: A Santa drawing on Luis' workspace with the tools used to create it

Far left: A sketch trying to capture the details of real people

Near left: Exploratory pencil lines

Since working on *The Angry Birds Movie*, I have been working entirely on character designs. Most recently, I worked on *The Lego Movie Sequel*, some 3D TV shows soon to be announced, and I am currently working on an upcoming feature animation film which is soon to be announced.

In this article I will share some of the important things I have learned over the years about working as a character designer and building a freelance business.

MEDIA AND TOOLS

I love traditional media. If you look at my Instagram feed you will see my processes and most of the time I mix media like there is no tomorrow! I love to experiment with all sorts of things: coloring pencils, watercolors, marker pens, coffee, gouache paint, ink, and random things I find.

As a student I would ask artists the brand of their tools but the brand is actually not crucial to your work (although of course you can get great results with some specific brands).

Instead, be more concerned with finding yourself as an artist and adapting to the tools you have around you to create an art piece.

I often look to the interviews of Carlos Nine, an amazing Argentinean artist, as I love how he talked about spending hours and hours drawing for himself, and experimenting with media. He only published forty percent of the work he created and the rest was just for his own pleasure and learning. I aspire to be like him! These days I enjoy using watercolor a lot; I like to adapt to the spontaneity of the medium and

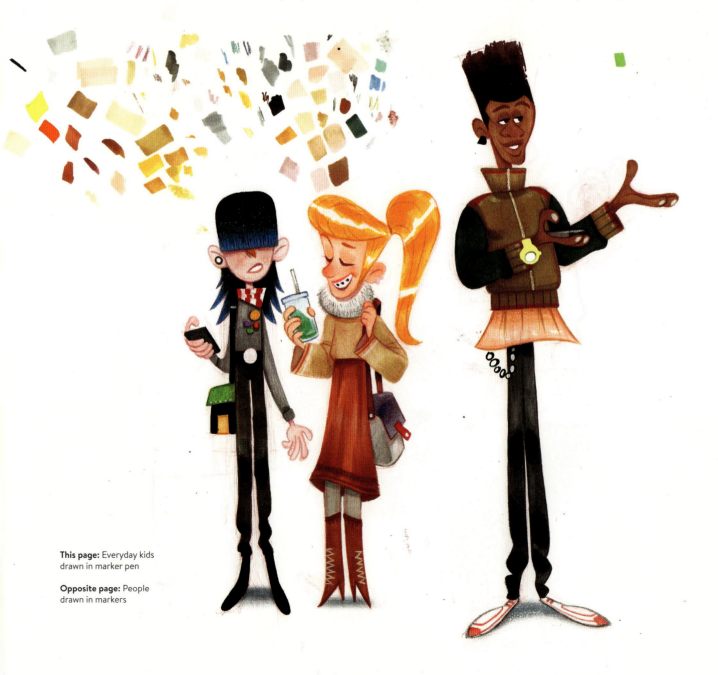

This page: Everyday kids drawn in marker pen

Opposite page: People drawn in markers

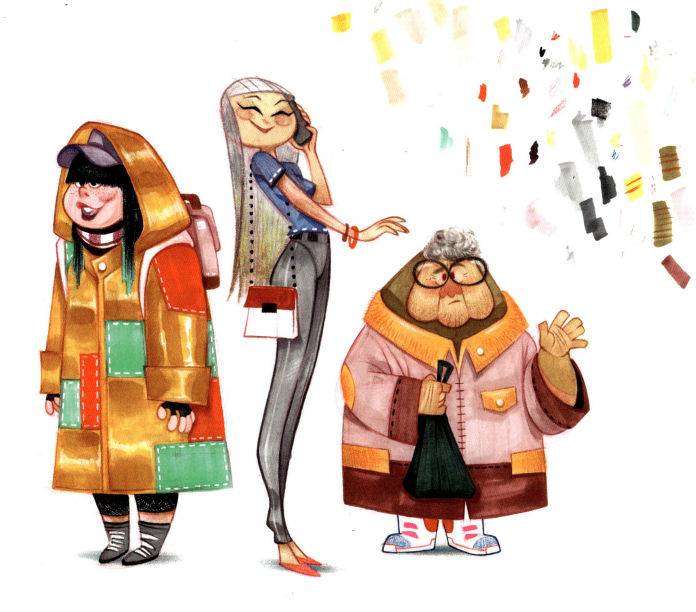

I am learning to peel off the fear that it creates. For professional work I use my Cintiq to draw but most of the time I start my designs on paper, scan them in, and then work with them in Photoshop. Explore the media and tools available to you but do not let them dictate the work you do. Use tools as an opportunity to find yourself as artist.

INDUSTRY GROWTH

It is incredible how many projects are being produced now; with work opportunities both in-house at studios and for freelancers. Through the internet it is now much easier to work with teams across borders. You can, for example, have a meeting using a shared screen and get immediate feedback from clients on your project deliveries. Having an

easy way to send your work where the client can open and review it immediately makes everyone's lives much easier. Character design is such an interesting field because you get to showcase your interpretation of life, and your experiences as a person, with other people.

You get to be an actor by putting yourself in the shoes of your characters and analyzing their backstory. You can enjoy a show more when you relate to the characters and their journey. That is what everyone in the industry wants to do: share those characters with the world and tell the story they have inside.

EDUCATION

As a student I had always dreamed of being a character designer, but I understood from

a very young age that in order to get there I needed to first understand design in general. You also have to compete in a world crowded with amazing character designers.

When you think about that, it is clear that it will be a very long path to achieve the success of the designers you admire. In my opinion, formal education is not essential for character design itself. Everyone should find the most effective way to learn for them; what is suitable for one person might be completely different for another.

You should aim to find your own way of doing things; with it you will find your own creative style, but more importantly, you will discover who you are as an artist.

"EVEN WHEN I'M AT WORK IF I DON'T KNOW HOW TO DO SOMETHING I OPEN GOOGLE AND LEARN IT. BY DOING THIS, INCORPORATING LEARNING INTO DAILY LIFE IS EASY!"

I personally like to learn with a tutor in front of me so I can get answers directly, but that is not the case for everyone. When I studied 3D animation I had some design classes with an architect, and until this day I can say those classes were the best and most effective way in which I learned things that I can apply in my everyday work on characters.

For something like learning to draw hands, you could take classes at school but ultimately the best references are your own hands and the time you put into practicing them. Often the most important factor in the success of your learning is the passion you have as an artist to spend time working hard to do what you love.

LEARNING IN EVERYDAY LIFE

If you are not learning in some way it is because you don't really want to. There is so much information out there now in books,

This page: In Luis' designs bears also wear pants

Opposite page: Luis' workspace mess when painting

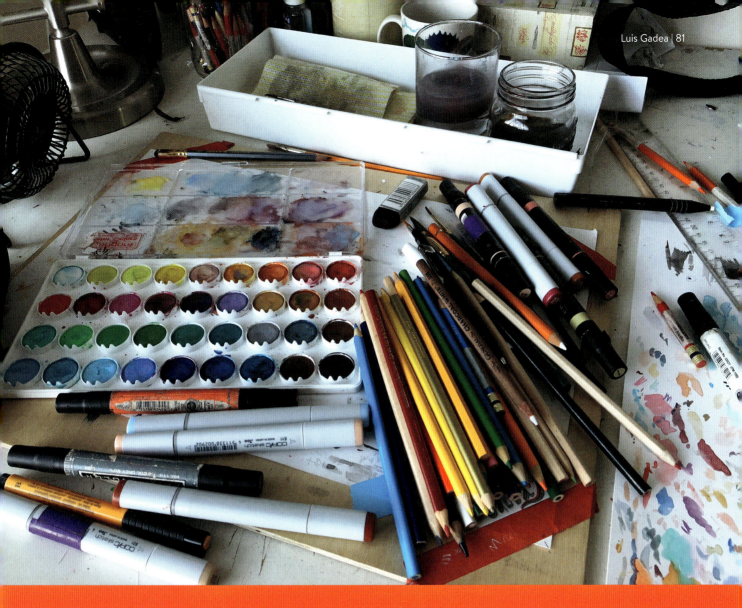

online schools, tutorials, and even YouTube tutorials. In fact, I started my own YouTube channel *Draw like a Kid* to show my processes and have fun while drawing. There are also low-cost tutorials on Gumroad that artists upload; I've bought a few of these myself to learn new things.

Try to spend every second you have available learning something new. For example, even when I'm at work if I don't know how to do something I open Google and learn it. By doing this, incorporating learning into your daily life is easy! Of course there are some things that might take more time and practice to learn than others, but your success depends on being willing to put that extra effort in.

To learn effectively you have to set yourself goals, which will lead to the accomplishment of larger goals. You also need to be self-critical (and this has been super important for me). There is a point where you need to stop showing your drawings to only your family and friends, and start showing them to people in the industry too to get their feedback. That is when the feedback gets interesting.

When my drawings were critically destroyed in a forum way back in 2005, it really affected me, but it pushed me to develop a sense of self-criticism. If you are aware of your weaknesses then you are on track to conquering them: you will notice them and work towards improving through practice and putting more time into those areas of weakness.

You have also got to recognize what it is you want from your work. Think of it as a salesman might: what is your product? Is it characters? Environments? Animation? Try to define this before you put the time into developing your skills in a particular area. It can happen of course that you might start with one thing and then find later down the road that you prefer to work on something else. That is also fine! At the very least try to understand what it is you want to start with so you can continue that while training yourself for something else later on if necessary.

CHOOSING AN EDUCATION FACILITY

If you do decide to get formal teaching, investigate the options as much as you can before choosing where to study. Email students

who have just graduated from the schools you are considering to get their feedback about each place. It will help a lot to get an idea of how they feel about studying at those schools. There will always be things about a school or course you don't feel fully comfortable about, but the key is to keep a positive mindset. I have friends who hated their school but they kept their focus on learning, graduated, and now do amazing things.

STUDIO VERSUS FREELANCE WORK

If I compare the time I've worked at studios and my time as freelancer, I've spent most of it in studios. It is only recently that I have started to freelance and it is amazing, but not easy!

At a studio you have a nine-to-five schedule; you know it, you accept it, and you adapt to it. When you are at home as a freelancer however, you need to keep the same mentality to organize yourself and focus. If not, then you wake up late, get distracted, and only start working later in the day.

At the beginning of my freelance career I asked my girlfriend to organize my day (she loves doing that sort of thing) so she created a Google Calendar schedule for me and I started organizing myself in that aspect. If I kept to that schedule then I could do my work and at the end of the day have more time to work on my own projects, which is what I wanted. These days I am back in a studio with a project cool enough for me to want to go back to that life.

Of course, an advantage of the studio life is that it gives you an assured paycheck so you do not have to worry about your finances. As a freelancer you have to always think ahead. It is essential to plan some projects in advance to ensure you have money for rent, food, and of course your art books (because you can't give up buying them). As a freelancer you also have to be able to embrace the loneliness of the job. At the studio however you still have some active social life.

Ideally everyone should experience both styles of work, freelance and in-house studio work, for a time to then decide which they like better. Maybe, like me, the best option for you is to go back and forth between the two.

DAILY WORKING LIFE

I start my days at 6:30 am going straight to the drawing table, coffee in hand. The very first thing I do is start getting ideas down or, if I already have one thought out, I try to finish it. I spend one hour on this and normally I record the process for my Instagram Stories. When 7:30 am arrives it is time for me to get ready and leave for work.

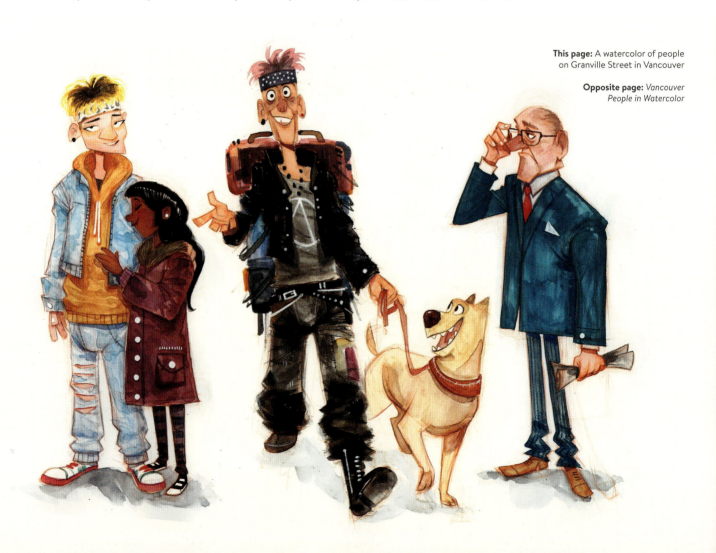

This page: A watercolor of people on Granville Street in Vancouver

Opposite page: *Vancouver People in Watercolor*

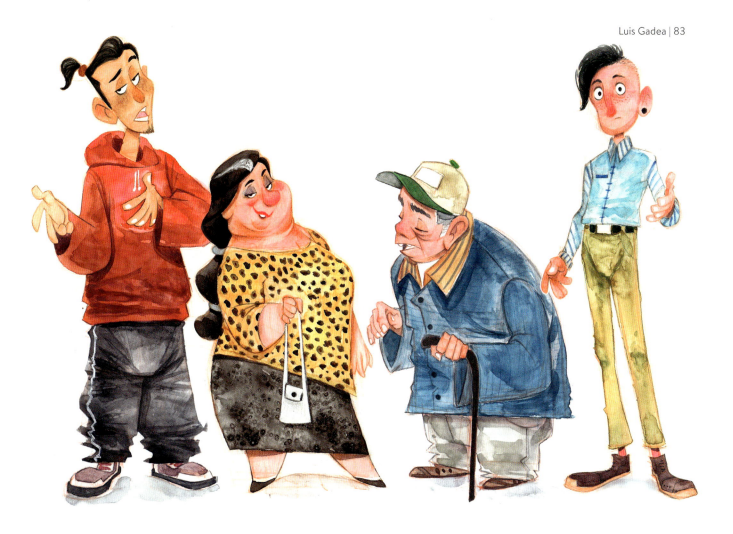

I take the train downtown everyday so I utilize these thirty minutes to make a proper post of a drawing on Instagram and answer client emails. It is amazing how fast that half-hour flies by.

I am at the studio by 9 am, when I do some really quick doodles to warm my hands up from the cold of Vancouver and then I am ready to work. I tend to sketch most of my tasks at once to get the first round of ideas for each out there; trying to not get into small unnecessary details. I work in the same way I would make a watercolor painting: I work in layer passes. If I am working on expressions I try to work through my list of different expressions in a very quick pass, and then spend the rest of the day refining them.

If I am designing a character from scratch on the other hand, I sketch all my ideas and then present them to get an initial round of feedback. I will then spend the rest of the day finalizing them for a more professional presentation. For this first pass of ideas I normally don't look at references, other than what I've been provided with. After the first feedback though I'll go back and look at references to develop a more specific look. The time frame for this process depends a lot on the project, and of course the deadlines, but most of the time I take a few days to get everything done to a stage that I am happy to present.

Most of my working days now are dedicated to performing creative tasks, and I don't deal a lot with meetings and such. I like them, but normally I will only have one or two meetings. When I was Animation Director on *Rocket Monkeys* I never had time to actually draw as I needed to be in almost every single meeting.

Alternatively, I did get to understand that side of the industry, and it was nice to embrace it and experience it.

After work I return home, eat, watch some Netflix for a bit to relax and then at around 9:30 – 10:00 pm I sit down for around two hours to draw. This time at the end of the day is for either my freelance work or my personal drawings.

ARTIST BLOCK

In a professional environment, the way you can cope with artist block will often depend on the situation. If the deadline is right away then you just have to hope for the best and finish the work no matter what! However, if the deadline is not imminent, there is time to do something about the block. In this case; stop, breathe, and think positively about how everything will be just fine (as most of the time it will be).

If you are struggling with artist block, go for a walk and get a coffee. Try to avoid thinking about the situation at all, to give yourself a mental break from the drawing. When you return from the walk, draw something unrelated in a sketchbook, just for yourself, and it might be a poor drawing but by doing a drawing with no stress it keeps your mind calm. After a while, try to accomplish the task again, but attempt a different approach than the first time around.

CREATING A PORTFOLIO

The most important thing about building a professional character design portfolio is knowing what it is you want to do. Understanding your true passion is a key step because it will show through in your portfolio and in your personal work.

For a character design portfolio, here are the top four things to focus on:

- **Life drawing:** showing that you understand the human body will demonstrate to your future bosses that you can rotate a body. They will see that you know how an arm bends and which muscles react in this movement, and that you are aware of weight and gravity and how they affect your character drawings.

- **Hands:** some of the hardest things to draw are hands, so practice them! There is beauty in hands and when a character has well drawn hands the design improves drastically. Practice by drawing your own, but also study how other artists do it. This will tell employers that you know what you are doing.

- **Eyes:** make sure you put some time into working on your character's eyes. Ensure the eyes are looking in the direction they are supposed to and that they are clear to read because the first thing people will look at is the character's face.

- **Good presentation:** present your designs and drawings properly. This does not mean they have to be cleaned up, if you have strong sketches they will do just fine, but learn how to present them in a way that shows your skills. Do not cut out arms or legs from the page or miss off hands. If you are adding color then take the time to do the paint work properly rather than rushing with the Paint Bucket tool. Be sure to present all your work in a high resolution with no pixelated images.

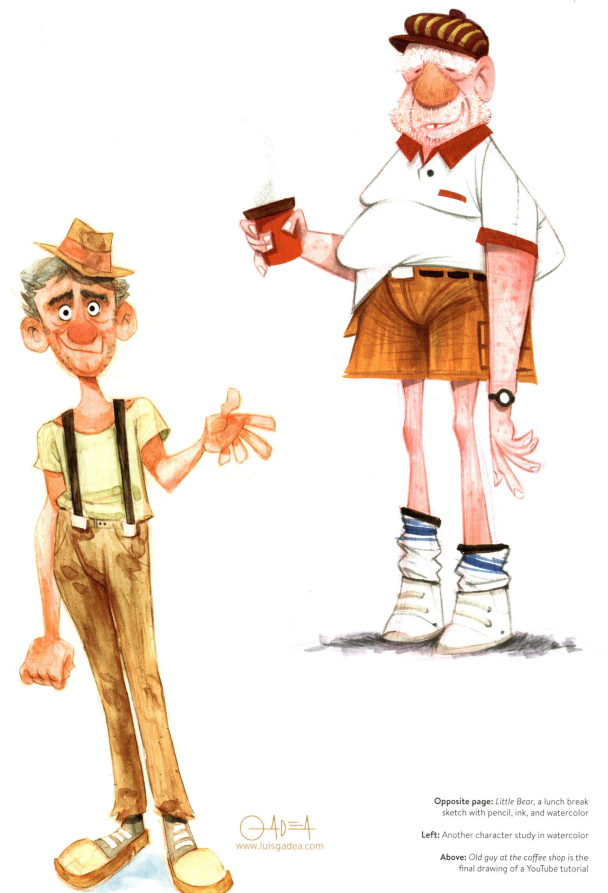

www.luisgadea.com

Opposite page: *Little Bear*, a lunch break
sketch with pencil, ink, and watercolor

Left: Another character study in watercolor

Above: *Old guy at the coffee shop* is the
final drawing of a YouTube tutorial

PROMOTING WORK ONLINE

Being constant in posting art online can attract the eye of employers. Work on what you have more fun doing too. For example, I draw everyday for myself as practice, to keep learning, and most importantly to have fun. This enjoyment then reflects in the drawings I post for people to see.

With the internet it is very easy to showcase your work, and there are hundreds of platforms available. Take advantage of the options available to you and show the work which will help clients find you.

INDUSTRY EVENTS

Attending industry events and networking is so important! I actually worked on *The Lego Movie Sequel* because I met the Production Designer for it at CTN Expo.

Events are awesome fun to attend! Just the experience of being in a convention walking around your favorite artists, and getting to talk to them is a great feeling. It gives you motivation, and as an artist this is important because when you are inspired no one can stop you from creating. I remember being completely inspired at CTN Expo by watching all of my favorite artists in person, and getting to talk and trade art with them. I came back home striving to create more art.

The second brilliant thing about industry events is the opportunity to connect with people and network, which is very important in the industry. You start getting to know artists and people involved in the industry who might in the future recommend you to a studio or for a specific project. Conventions are a place to make new friends and stay in contact for future projects!

Opposite page: A sketchbook page

This page: Exploring posing with negative space

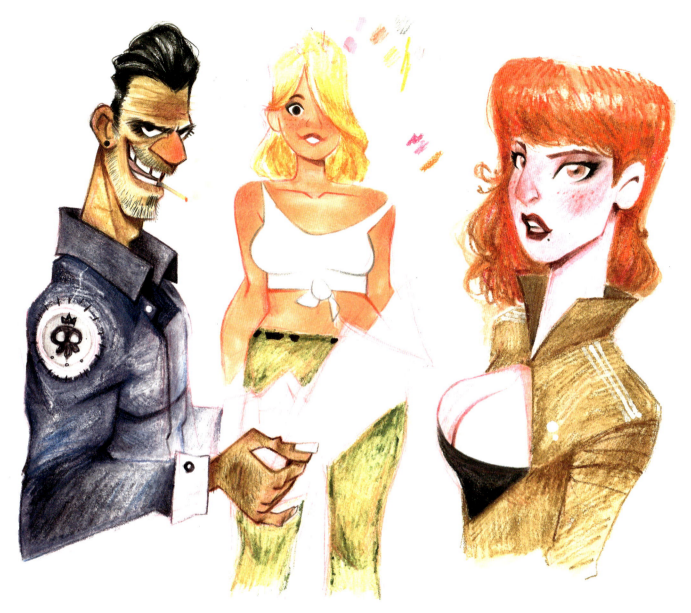

The animation industry is much like a community and you'll see familiar faces over the years moving from one project to another. You never know if a fellow co-worker will be your boss on the next project; that happens all the time. Be nice to your co-workers and bosses. You don't want to be that artist no-one wants to work with. If you are humble, not problematic, and polite, people will remember you and will pass along your name for future projects.

Finally, we artists tend to be a bit shy but learning to start a conversation with your fellow artists is vital. If you are a student, ask questions; others have probably had the same questions too as everyone has been in the same position at some point in their life.

OBSERVE FROM LIFE

The most useful thing you can do as a character designer is to observe from life. I find most of my inspiration in this way, and then I apply the knowledge I have gathered to what I create. You will find the best inspiration for your characters in your everyday life walking beside you, or standing on the train, at the zoo, sitting in a café, or shopping at the supermarket. Study the world around you and you will learn to create interesting, believable characters. ♦

> "YOU NEVER KNOW IF A FELLOW CO-WORKER WILL BE YOUR BOSS ON THE NEXT PROJECT"

GO RETRO

Christophe Jacques

In this article I will show how to create simple characters with a retro touch. The examples here are drawn in Adobe Illustrator and Photoshop using a Cintiq. I will also show you how to create dynamism, even with the most modest shapes.

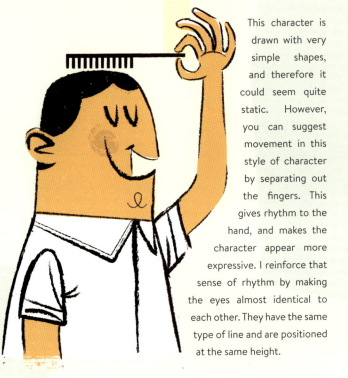

This character is drawn with very simple shapes, and therefore it could seem quite static. However, you can suggest movement in this style of character by separating out the fingers. This gives rhythm to the hand, and makes the character appear more expressive. I reinforce that sense of rhythm by making the eyes almost identical to each other. They have the same type of line and are positioned at the same height.

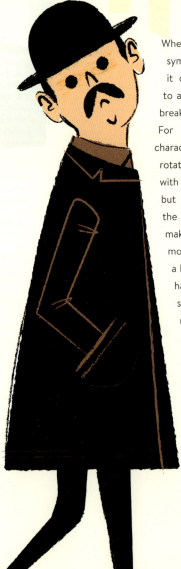

When drawing a symmetrical figure it can be interesting to add something that breaks the symmetry. For example, this character's head is rotated. He is drawn with very basic shapes but the movement of the leg and the head make the forms seem more natural, and even a bit intriguing. What has this character seen? Why does he rotate his head? Adjustments like these make the character visually more appealing and life-like.

Action and movement can also be suggested with lighting. The light in this drawing comes from the left. As the character's eyes are also turned sharply to the left we can deduce that there is something going on out of view. Note how this character's body also leans to the right to counter the attention on the left. Together with the lighting this creates a sense of movement.

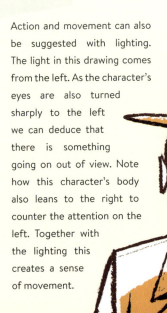

This drawing shows how to create dynamism in a simple design by drawing the head turned in a different direction to the body. The sweeping directional lines of the hair and scarf also suggest movement. Just by looking at those lines, you can see the character is sat in a windy place.

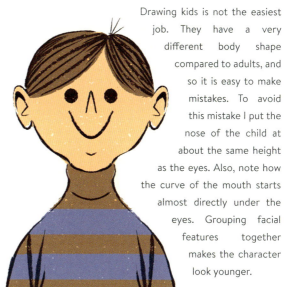

Drawing kids is not the easiest job. They have a very different body shape compared to adults, and so it is easy to make mistakes. To avoid this mistake I put the nose of the child at about the same height as the eyes. Also, note how the curve of the mouth starts almost directly under the eyes. Grouping facial features together makes the character look younger.

TECHNIQUES

Find the technique that suits you best. Do you think you are better working in 3D or 2D? Do you want to use color or not? You should try to find answers to all of these questions and the best way to find out is to try every technique out there. Think about which technique works well for your character as the techniques you use should not get in the way of creating awesome characters.

Do not be discouraged if your technique experiments do not work out the way you wanted them to. Sometimes it is just an early stage of the development process and learning to use new techniques or tools takes persistence. It took me a year to learn Adobe Illustrator and at first I did not like it. Now it is my preferred tool for creating characters. Practice makes perfect after all.

Patterns on clothes are always fun and there are different ways to use them in a design. You can wrap a pattern around the body shapes, as they appear in real life on a 3D form. However it can also be visually appealing to do the opposite. It may not seem natural to use flat patterns, but they create an interesting contrast. In general a flat pattern works better on a symmetrical character, or when you draw your character with very simple shapes like this one.

All images © Christophe Jacques

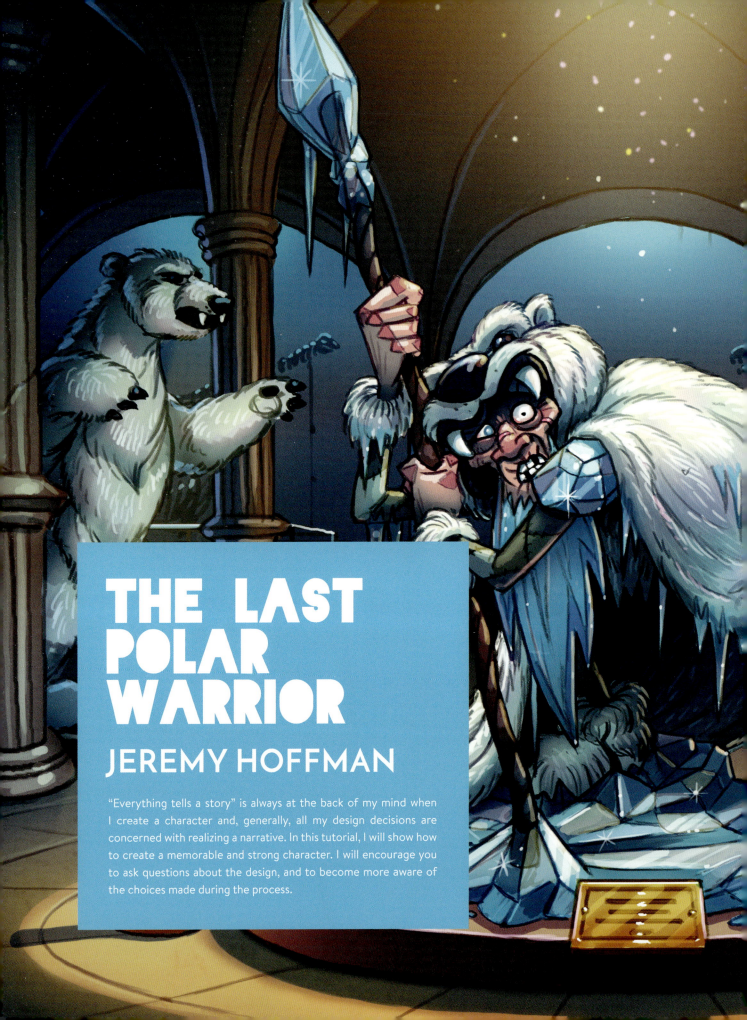

THE LAST POLAR WARRIOR

JEREMY HOFFMAN

"Everything tells a story" is always at the back of my mind when I create a character and, generally, all my design decisions are concerned with realizing a narrative. In this tutorial, I will show how to create a memorable and strong character. I will encourage you to ask questions about the design, and to become more aware of the choices made during the process.

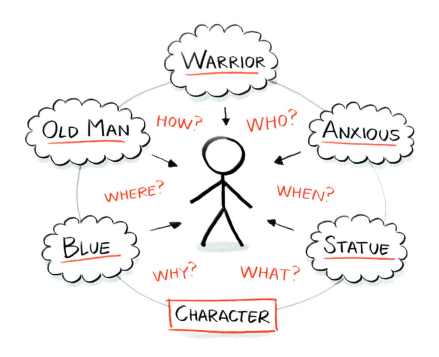

For this character, five randomly chosen keywords were given to me: "old man," "warrior," "anxious," "statue," and "blue." These words will be the starting point from which an impressive, memorable, and story-telling character design needs to be created. Throughout this tutorial I will be working on my iMac, Cintiq, and using Adobe Photoshop.

WHERE TO BEGIN?

Let's see what information there is already in the brief. In this case, there are five randomly chosen keywords which might trigger a great idea immediately. Be careful not to fall in love with one idea too soon though; it pays to do thorough research before selecting one.

Dive into a pool of knowledge and collect as much information as possible about where you could take this design. Start by asking questions about the keywords and writing them down. For example; what is the exact definition of a warrior? What is the symbolic meaning of the color blue? The answers might inspire you to come up with a more refreshing and original idea than your first.

THE POOL OF KNOWLEDGE

Where do you collect information and look for inspiration? I browse the internet, books, look around in real life, ask other people, or go to a museum. Anything that helps to get extra information about the five keywords, or is inspiring, is helpful. During the research phase, try to analyze what you find, and not just copy it. If you really understand your material, you will be able to make more conscious decisions later on. Sketch or write down all the separate ideas for each keyword, to be used in the next steps.

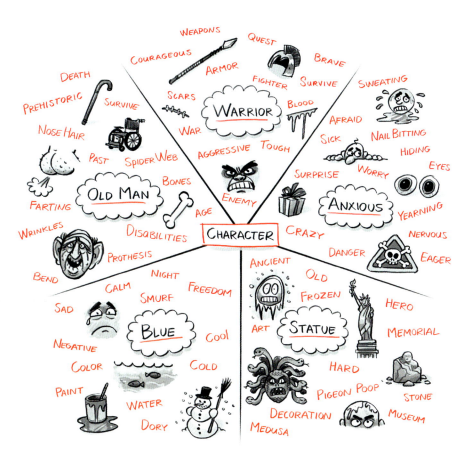

Top: Try to get a better understanding of the keywords by asking questions about them

Left: Take detailed notes of things associated with the keywords that can help generate new ideas

CONNECT THE DOTS

Now that the information has been gathered, it is time to create strong, and sometimes crazy, connections between the otherwise random keywords. It may already be possible to create a small backstory out of keyword combinations. A backstory can help answer questions about who the character is and why they look the way they do. Have some fun with it and start creating concept sketches of any idea that captures your imagination.

Do not be afraid to show your sketch ideas to other people and ask for feedback. Did they understand the story idea and did it trigger the right reaction? Ask them questions to understand the received feedback.

ONCE UPON A TIME...

Time to pick a story idea! Explore strong arguments for choosing one idea over another. Can you explain how the keywords are reflected in your character design and why that works? I find visualizing a few story moments helps to connect to the character and understand their world.

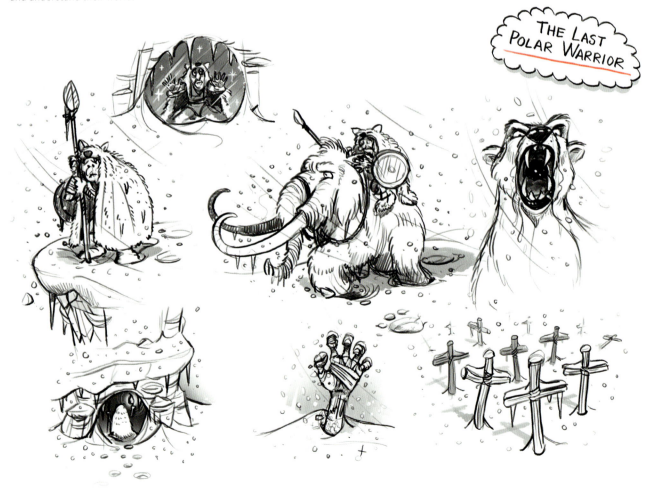

THE LAST POLAR WARRIOR

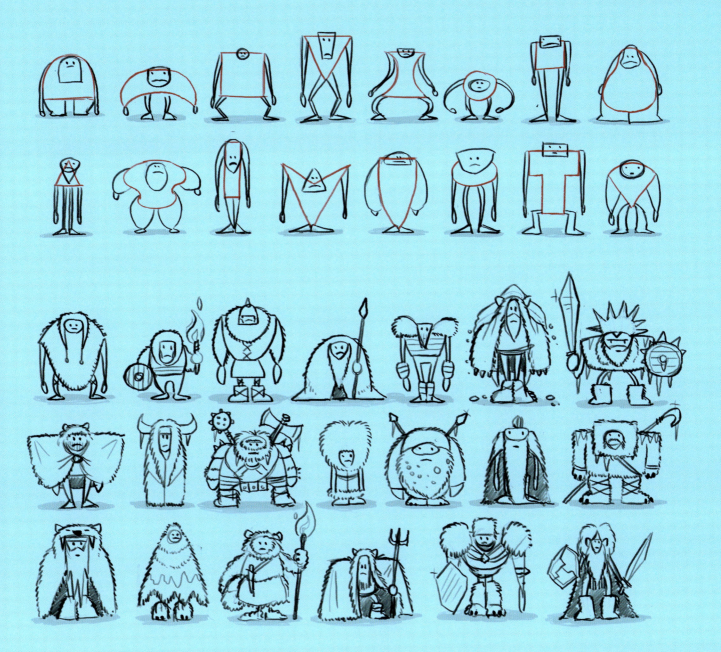

PLAY WITH SHAPES

In my case I decide to go for the story of "the last polar warrior." I imagine a polar warrior who lived at the cold (and therefore associated with blue) North Pole more than ten-thousand-years ago (meaning he is very old). He is a warrior who fought in many battles and eventually became the lone survivor of his clan. Overcoming the dangers of nature year after year, he ends up as an anxious old man who fears becoming frozen like a statue and being forgotten.

From the sketching stage, you may already have a decisive impression of where to go with the look of the character. It is worth trying to capture this look in general shapes.

As you can see from my thumbnails, each character consists of shapes that create a certain silhouette. A clearly shaped form is easily readable and it can instantly convey a sense of story.

Start by creating a page of thumbnails of different silhouettes centered on a variety of simple shapes. To define the silhouette further, repeat the step and add more details to the elements that form the silhouettes. For my character, I try to project three of my keywords onto the silhouette: warrior, old man, and blue, through sharp shapes and weather design elements that suggest cold and ice.

Opposite page (top): Mix up and combine the keywords to generate some fun and refreshing story ideas

Opposite page (bottom): Create backstory concept sketches to connect with the character

Above: Generate diverse and interestingly shaped silhouettes that reflect the character's identity

"WHICH PARTS OF THE CHARACTER ARE BONES, FAT, OR MUSCLE, AND WHERE ARE THE MOST IMPORTANT JOINTS? KNOWING THIS INFORMATION GIVES GREATER INSIGHT INTO HOW THE CHARACTER WILL MOVE"

Notes:
Icicle = Triangle ▽ Sharp – Cold – Pointy
Bones = Square ▨ Hard – Old – Straight
Clothes = Round ◉ Soft – Warm – Curved

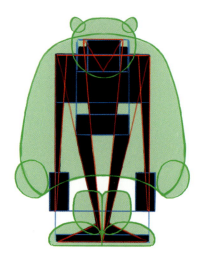

ANALYZE THE SILHOUETTE

Looking at the thumbnails, is there one that stands out? Try to come up with a clear reason why a certain silhouette works better for the character and story. Analyze the shapes used. Why did you use them? Is there something conceptual they refer to? I choose to work with triangles and squares for the character's figure to suggest aged bones and icicles. Then I drape the figure in more rounded shapes to insulate the character from the cold weather.

By assessing how each shape supports the design idea, this creates depth and contrast, not only from the outside, but also from within the design. It does not mean that the final silhouette is entirely confirmed, but it helps to go in a certain visual direction with purpose.

TO THE BONE

Often the silhouette of a character is based on the character wearing an outfit. Personally, I always want to know what the body looks like, and how it is built, underneath the outfit. Which parts of the character are bones, fat, or muscle, and where are the most important joints? Knowing this information gives greater insight into how the character will move and how the body will react under different circumstances. Last, but not least, working out the character's skeleton and undressed

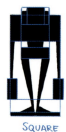

SQUARE + TRIANGLE V.S ROUND = CONTRAST

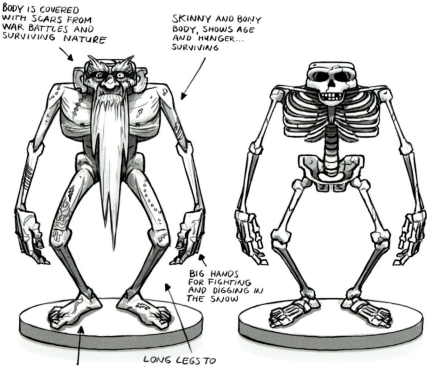

BODY IS COVERED WITH SCARS FROM WAR BATTLES AND SURVIVING NATURE

SKINNY AND BONY BODY, SHOWS AGE AND HUNGER... SURVIVING

BIG HANDS FOR FIGHTING AND DIGGING IN THE SNOW

BIG FEET TO WALK ON THE SNOW

LONG LEGS TO KEEP HIS BODY ABOVE THE SNOW

form will give more insight into how the clothes fit and react to the body.

For my character, I continue trying to project the keywords of warrior, old man, and blue onto the body. You can see that the body is covered in scars which suggest both his warrior past and his age. He is crouched with age yet his gangly body has clearly adapted for cold conditions.

READ THE FACE

As with the body, the face can also be broken into shapes and assessed. Again, ask questions about why you are making certain choices. What makes this face so special? Does the character have unique features? How

memorable is their face? How does the face work? What story does it need to tell?

Keep the features simple and readable. It is much easier to animate the face and create strong expressions when clear shapes are used as a base. I embellish the shapes of this face with exaggerated ears and nose to show age, and facial hair that mimics the icicles of his environment.

Opposite page (top): Think about shape choices and how they create contrast

Opposite page (bottom): Understand how the body works to bring the character to life

Below: Every part of the face can tell a story, so be aware of what is being conveyed

ASK FOR FEEDBACK ▶
Do not be afraid to ask for feedback. Criticism can help open your eyes and expose possible weaknesses in the design or idea. Do not limit yourself by asking for feedback only from other artists, but ask non-artists as well. They often have a fresh and honest view on what you are creating. If they do not understand the idea, maybe you need to adjust it. To avoid frustration about adjustments, ask for feedback at an early stage of the process, not when it is almost finished and rendered at the end.

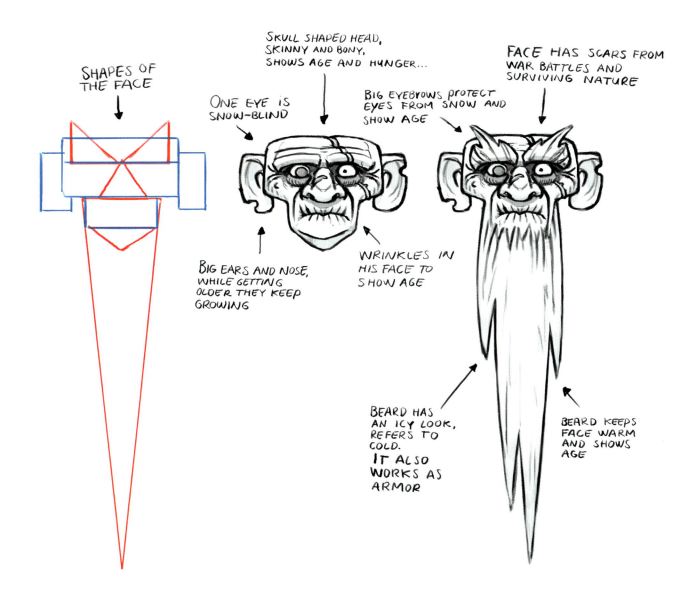

SHAPES OF THE FACE

SKULL SHAPED HEAD, SKINNY AND BONY, SHOWS AGE AND HUNGER...

FACE HAS SCARS FROM WAR BATTLES AND SURVIVING NATURE

ONE EYE IS SNOW-BLIND

BIG EYEBROWS protect EYES FROM SNOW AND SHOW AGE

BIG EARS AND NOSE, WHILE GETTING OLDER THEY KEEP GROWING

WRINKLES IN HIS FACE TO SHOW AGE

BEARD HAS AN ICY LOOK, REFERS TO COLD. IT ALSO WORKS AS ARMOR

BEARD KEEPS FACE WARM AND SHOWS AGE

CLOTHES MAKE THE MAN

For me, a good outfit says something about the character wearing it; it should make a statement. It has to be easy to read, recognizable, and also memorable. That is what creates the magic. Look at any of your favorite characters from movies or comics – can you describe their outfit? I bet they are not particularly complex in color, silhouette, and details. Maybe there is only one detail or design element that stands out strongly.

Emulate this by keeping the work simple. Do some additional research, as before with keywords, to get more information about how the outfit can support the design. I turn that rounded insulation I defined earlier into a cloak made from a polar bear's skin and stitched-up clothes, which supports the idea that he has been a warrior for a long time.

PROPS

Using props or a side-kick for a character is optional and depends on the brief or backstory of the character. However, they can be a great way to give them more depth and contrast. If you choose to include a prop think about how and why the character interacts with it. The chosen prop sets certain expectations so try to use it to enhance the storytelling.

For this design, I consider adding a torch and a spear. The torch is very functional for the character but it may not work with the sense of cold I am trying to build. The spear too is functional for this warrior but it works much better as the spearhead can be made from ice.

Top: Clothes can really add to the character's backstory

Bottom: Props can be an important extension of the character and story

Opposite page (top): Push the character's expression by utilizing all of the facial features

Opposite page (bottom): Project the character's personality through their pose

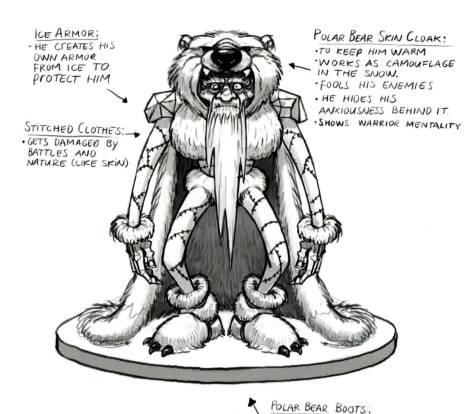

ICE ARMOR:
· HE CREATES HIS OWN ARMOR FROM ICE TO PROTECT HIM

STITCHED CLOTHES:
· GETS DAMAGED BY BATTLES AND NATURE (LIKE SKIN)

POLAR BEAR SKIN CLOAK:
· TO KEEP HIM WARM
· WORKS AS CAMOUFLAGE IN THE SNOW.
· FOOLS HIS ENEMIES
· HE HIDES HIS ANXIOUSNESS BEHIND IT.
· SHOWS WARRIOR MENTALITY

POLAR BEAR BOOTS:
· KEEPS HIS FEET WARM
· FOOTPRINTS FOOL THE ENEMY

FIRE: TO KEEP HIM WARM, PROVIDE LIGHT, COOK FOOD, MELT SNOW AND SCARE ANIMALS AWAY

POINTED HEAD MADE OUT OF ICE, FROZEN TO AN OLD STICK

SPEAR IS USED AS A WEAPON, BUT ALSO USED AS A WALKING STICK (BECAUSE HE'S OLD). HE ALSO USES IT TO SEARCH FOR CREVASSES

ROUGH WOOD GIVES IT A FIRM GRIP

FACIAL EXPRESSIONS

Bringing the character to life is always fun to do. In this step, explore the possibilities for expressing emotions and attitude. This is not only about showing how the character feels, but also about triggering an emotional connection with the audience.

Try to really exaggerate the emotions in the design. Do not limit yourself by using just the eyes and the mouth; use all of the facial features to push and stretch the character's features into the correct expression. Even a hat can be a part of this, so in one of my drawings I explore a polar bear's head as a hat. Avoid symmetry as this will make the expression less interesting and will instead create contrasts in the shapes and directional lines.

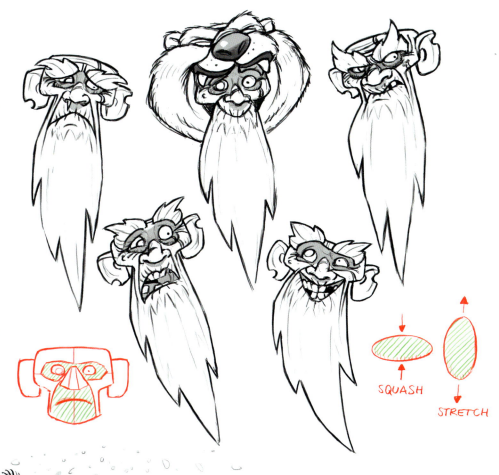

SQUASH

STRETCH

BODY LANGUAGE

The body reacts in different ways to certain emotions or actions, and this will affect how the character is posed. How does their body language show what they are feeling or doing? The way the character moves or acts needs to match their personality and the situation they are in. The stronger and more convincing the pose and expression, the bigger the chance your audience will connect with the character.

Review the sketches and notes about the body underneath the clothes to create a more convincing pose based on how the body is built. I try out two very different poses: one showing the character in an attacking warrior-like stance, masked by his polar bear skin cloak; the second where he is in a hunched, protective pose that supports the keyword "anxious." I will continue working with the anxious pose as this is most suitable for my brief.

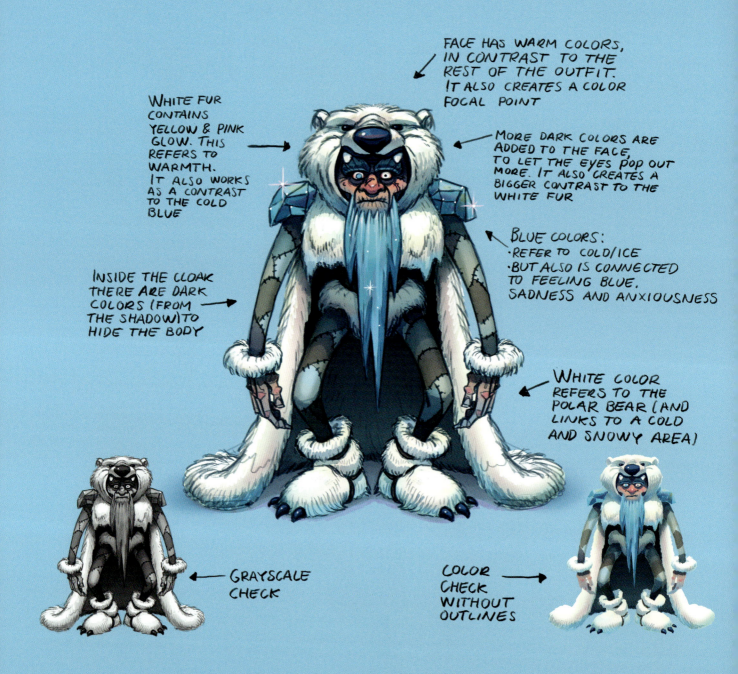

FACE HAS WARM COLORS, IN CONTRAST TO THE REST OF THE OUTFIT. IT ALSO CREATES A COLOR FOCAL POINT

WHITE FUR CONTAINS YELLOW & PINK GLOW. THIS REFERS TO WARMTH. IT ALSO WORKS AS A CONTRAST TO THE COLD BLUE

MORE DARK COLORS ARE ADDED TO THE FACE, TO LET THE EYES POP OUT MORE. IT ALSO CREATES A BIGGER CONTRAST TO THE WHITE FUR

INSIDE THE CLOAK THERE ARE DARK COLORS (FROM THE SHADOW) TO HIDE THE BODY

BLUE COLORS:
· REFER TO COLD/ICE
· BUT ALSO IS CONNECTED TO FEELING BLUE, SADNESS AND ANXIOUSNESS

WHITE COLOR REFERS TO THE POLAR BEAR (AND LINKS TO A COLD AND SNOWY AREA)

GRAYSCALE CHECK

COLOR CHECK WITHOUT OUTLINES

COLORS

Adding color is an important part of a design. Color can say a lot about a character. It can reflect their emotions or make a statement about the character's identity. Color can also be used to guide the viewer's eye to certain important aspects.

Try a few different options if you are in doubt about which colors to use. For this warrior I, of course, use shades of blue as this was specified in the keywords, and also implies that he is sad or anxious. To create some contrast I use warmer colors on the face and touches of yellow and pink to the white fur of the polar bear cloak.

Always check the contrast values of the colors in grayscale. Try to avoid colors that have the same contrast values as this will cause the different elements to blend together. Aim instead to create a nice balance in the contrast levels with a clear focal point and keep the shapes readable.

This page: While adding colors, think about creating contrast and focal points

Opposite page: Compile the successful design ideas together to create a final design redrawn for presentation

"ALWAYS CHECK THE CONTRAST VALUES OF THE COLORS IN GRAYSCALE. TRY TO AVOID COLORS THAT HAVE THE SAME CONTRAST VALUES AS THIS WILL CAUSE THE DIFFERENT ELEMENTS TO BLEND TOGETHER"

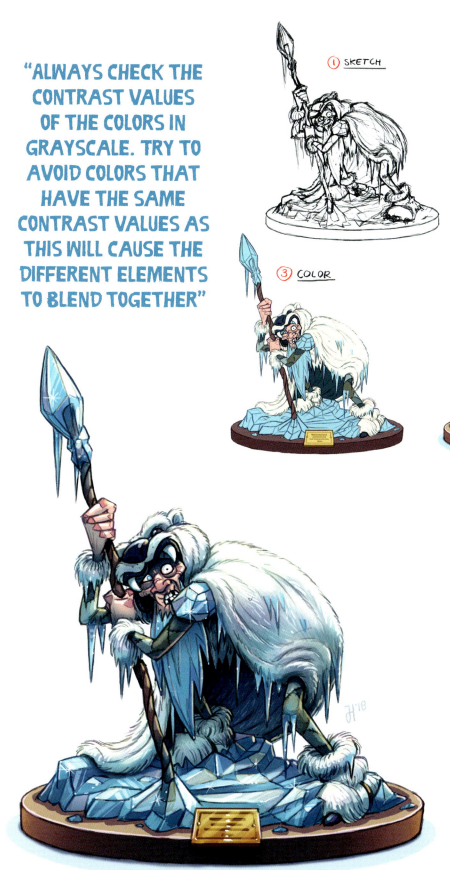

① SKETCH

② CLEAN-UP

③ COLOR

④ RENDER

BRING EVERYTHING TOGETHER

Now we have gone through all of these steps in creating a character, I hope you feel comfortable with your basic design. It is important to believe in your own character and that this is the one that convincingly tells the story. If not, there is still time to go back and adjust it!

Once happy, move on to thinking about how the final design can be presented. Get the character into a final pose that depicts a clear emotion or point in the story. Choose something that particularly reflects their personality. At this point I decide to bring another of the keywords into the mix by making the character himself the statue. I like the idea that he has become frozen in time, so I sketch him in an anxious pose on a podium then clean-up, color, and render the design ready for presentation.

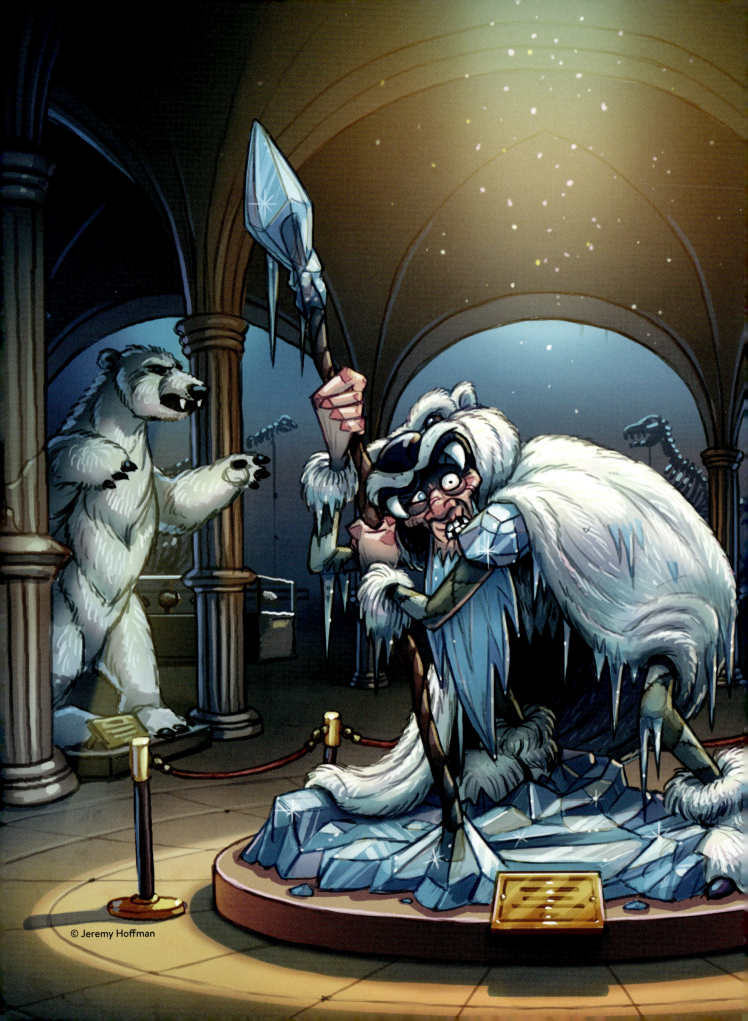

© Jeremy Hoffman

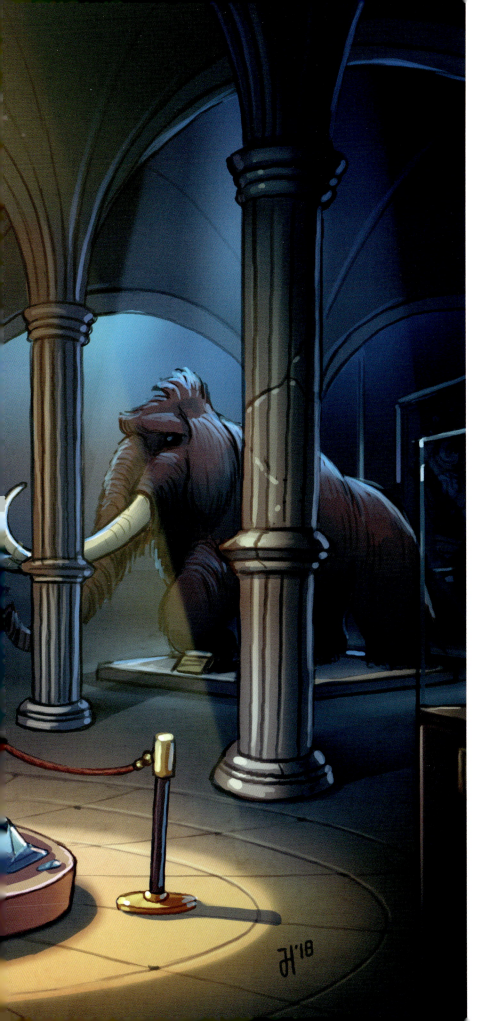

"OVERCOMING THE DANGERS OF NATURE YEAR AFTER YEAR, HE ENDS UP AS AN ANXIOUS OLD MAN WHO FEARS BECOMING FROZEN LIKE A STATUE"

THE FINAL STORY MOMENT

Depending on what the goal of the character design is, you can decide how far to go with rendering the final character. To add an extra flavor or dimension to the design, add to the mood through ambient light and shadow. For my presentation, I add a scene to give extra story details, a spotlight from above, and a final twist of the warrior frozen, statuesque, in a museum.

This spread: When presenting the final design, a picture can be worth a thousand words

DRAWING FROM LIFE ▶

Ahead of designing, go out and draw people from life. Not only does it help you to warm up, but you will also learn a lot from it. This practice forces you to be observant and creates a greater awareness of how people act, look, pose, and move.

Personally, I never leave the house without my sketchbook and pencils. I try to practice it daily wherever and whenever I can. Keep practicing, be patient, and your skills will improve. Those skills will in turn help you to become a better character artist.

CONTRIBUTORS

KENNETH ANDERSON
Character Designer & Illustrator
charactercube.com

Kenneth has worked on games, animations, and illustrations for over a decade through his freelance business Creature Cube.

LUIS GADEA
Character Designer
& 2D Animator
luisgadea.com

Luis has worked on animated commercials, TV series, and feature films. He often uses preschool art supplies to challenge himself.

JEFF HARVEY
Illustrator at Cedar Fort, Inc.
jeffharveyart.com

Jeff went to school in Utah where his love for children's books blossomed. He still lives in Utah, living his illustration dream.

JEREMY HOFFMAN
Art Director at GameHouse
Instagram:
@theheartofjeremyhoffman

Jeremy began work as an artist in the gaming industry around twelve years ago, following his heart by telling stories with his artwork.

NIKOLAS ILIC
Character Designer
& Visual Development Artist
Instagram: @nikolas.ilic

Nikolas grew up in Canada and attended Sheridan College where he studied Animation. He now works in the animation industry.

CHRISTOPHE JACQUES
Illustrator
Instagram: @atelier_la_fermette

Christophe is an illustrator living and working in Belgium. He has worked for clients all over the world, focusing on children's illustrations.

KACEY LYNN
Freelance Illustrator
& Character Designer
Instagram: @untroubledheart

Kacey Lynn is a character designer and illustrator with a passion for fairy tales and a penchant for daydreaming, drawing, and writing.

PERNILLE ØRUM
Character Designer & Illustrator
pernilleoe.com

Pernille was an animator and visual developer. She is now a freelance character designer and works on Warner Bros *DC Superhero Girls*.

KAROLINE PIETROWSKI
Freelance illustrator
karolinepietrowski.de

Karoline is an illustrator from Germany. She has recently worked for Adobe and published a book about her online game, *ONFORM*.

GUILLE RANCEL
Art Director at Fu Educulture
behance.net/guillermoperezrancel

An illustrator and 2D animator, Guille works on comic books and animation. He has also worked on video games, advertising, and apps.

STEPHANIE RIZO GARCIA
Freelance Character Designer
stephanierizo.com

From California, Stephanie studied Narrative Illustration and now works freelance for companies including Disney TVA, and Warner Bros.

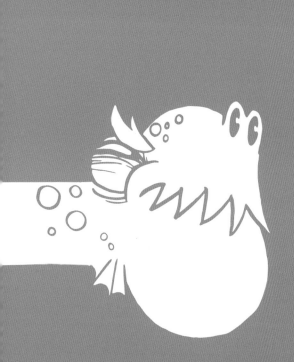